THE ART OF BUDO

THE ART of BUDO

BUDO

The Calligraphy and Paintings of the
MARTIAL ARTS
MASTERS

John Stevens

SHAMBHALA

Shambhala Publications, Inc.
2129 13th Street
Boulder, Colorado 80302
www.shambhala.com

Cover art: *Daruma* by Tesshu Kobo, courtesy of Alex Greene
Cover design: Kate E. White
Interior design: Gopa & Ted2, Inc.

9 8 7 6 5 4 3 2 1

First Edition
Printed in Singapore

Shambhala Publications makes every effort
to print on acid-free, recycled paper.
Shambhala Publications is distributed worldwide by
Penguin Random House, Inc., and its subsidiaries.

Library of Congress Cataloging-in-Publication Data
Names: Stevens, John, 1947– author.
Title: The art of budo: the calligraphy and paintings
of the martial arts masters / John Stevens.
Description: First edition. | Boulder, Colorado: Shambhala, [2022]
Identifiers: LCCN 2021055959 | ISBN 9781645470540 (trade paperback)
Subjects: LCSH: Zen calligraphy—Japan. | Zen painting—Japan.
Classification: LCC NK3633.5 .S74 2022 | DDC 759.952—dc23/eng/20220519
LC record available at https://lccn.loc.gov/2021055959

CONTENTS

Acknowledgments vii

Introduction 1

Part One: Edo 5

Part Two: Meiji 59

Part Three: Modern 111

Part Four: Tesshu 153

Resources 237

Artist Biographies and Reading Lists 239

Credits 267

About the Author 269

ACKNOWLEDGMENTS

SPECIAL THANKS go to my longtime editor at Shambhala, Beth Frankl, and assistant editor Emily Coughlin. Wonder-worker design director Lora Zorian, who has also worked with me for many years, deserves special praise for her great efforts on this challenging project.

I am grateful to the many friends who provided me with photos of the treasured pieces in their collections (in alphabetical order): Richard Bowles; Eamonn Devlin; Christopher Forman; Beth Frankl; Alexander M. Greene; Gordon M. Greene; Felix Hess; Swami Ishwaranda; Ben Johnston; Andy Kay; Christine Kilian; Kenneth Kushner; Robert Matsueda; Albert Mercado; Joshua Michaell; Naej Collection; Wolf Nickel; Robert Noha; Milard Roper; Junichi Tokeshi, MD; and Leslie Wright.

THE ART OF BUDO

INTRODUCTION

In my lifelong spiritual quest, I have read hundreds of sutras; plowed through pages and pages of philosophical texts; grappled with koan collections; analyzed thousands of poems; searched through biographies; meditated for hours; and interacted with many teachers, good and bad. However, I have gained the most from the contemplation, appreciation, and inspiration of the "ink tracings" of the great masters.

In East Asian culture, brushwork is considered a "mind seal"—a single stroke can reveal what is in a person's heart. It can also express the essence of a master's teaching. Since it is not the formation of the characters but the spirit behind the composition that matters, few of the most esteemed examples of brushwork were by professionals—and many masterpieces were by martial artists. In fact, Wang Xizhi, venerated as the greatest calligrapher in Chinese history, was a Tang dynasty general.

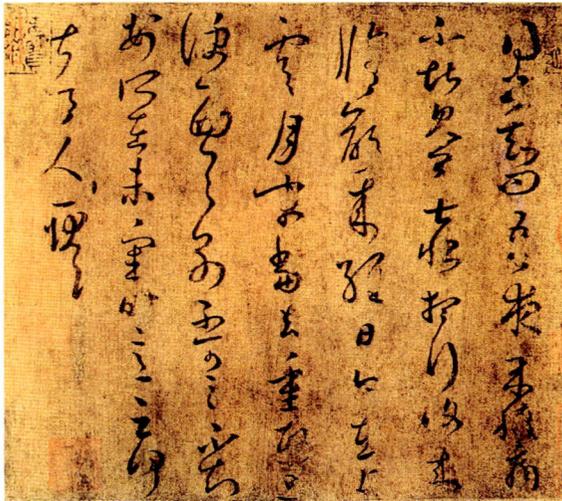

Portion of a facsimile of calligraphy by Wang Xizhi.

This book focuses on the brushwork of the budo masters of Japan. What defines a budo master? It refers to one who is well accomplished in all the technical aspects of the martial arts and, more importantly, the strategy behind warriorship. Strategy involves the ability to correctly evaluate an opponent's strengths and weaknesses, both material and psychological. However, one can qualify as a budo master even if one never wielded a weapon or stepped on a battlefield. Although masters such as Takuan, Hakuin, and Sengai never touched a weapon as part of their Buddhist vows, they were as skilled as the best martial artists. Despite being frequently attacked by highwaymen, rogue samurai, irate *daimyo* insulted by criticism of their behavior, and a host of other miscreants, the masters emerged unscathed by getting out of the way, literally and figuratively.

In the fifteenth-century koan collection *Shonankattoroku* (no. 69), there is this example: When her husband was killed in battle, Sawa became a nun to pray for her departed loved one. She shaved her head and entered Tokei-ji (the temple in Kamakura reserved for widows and divorcees), taking the name Shotaku. She devoted herself to Zen practice for many years, eventually being appointed abbess of Tokei-ji. One evening on the way back from a regular interview with her master at Engaku-ji, she was accosted by a would-be rapist. When the attacker threatened her with a sword, she immediately pulled out a sheet of paper from her sleeve, rolled it up like a sword, and thrust it directly at his eyes. He was unable to strike back, mesmerized by her intense energy. When he turned to run, she shouted a "Katsu!" so powerful it knocked him over. She then whacked him on the head with the paper sword. He got up and fled in terror.

Another example: Zen Master Shoju was well known for thrashing arrogant swordsmen. One day, a pompous samurai visited Shoju and grandiosely expounded his theories on the art of the sword. Shoju listened politely for a while but then suddenly leaped up and pummeled the samurai unmercifully, exclaiming, "You are full of nothing but hot air!"

Word of Shoju's startling behavior created a stir among the proud samurai swordsmen. They doubted that Shoju could better any of them without the element of surprise. A group of confident swordsmen was assembled. Shoju challenged them to strike, and not one could land a blow;

on the contrary, Shoju delivered a counterblow with his short wooden scepter, giving each one a sharp rap on the head. Thoroughly humbled, they asked him for his secret. "If your mind is free of deluded thoughts, nothing will disturb you, not even a sword attack," he replied.

While many budo masters were heavily influenced by Zen Buddhism, others were not—they drew on their experiences with esoteric Buddhism, Shinto, Confucianism, Daoism, folk religion, and other traditions. Like Zen, the most effective budo teachings are short and to the point. Due to the compact medium—a single sheet of paper—the essence of a master's teaching is limited to a few characters; typically a one- or two-line phrase or often only a single "one-word barrier." Many budo masters painted as well. Although a few were excellent artists, the majority of their paintings are simply composed, and some are more like cartoons, often graced by a laugh-out-loud humor.

This book begins with two pieces, a painting and a calligraphy, by Miyamoto Musashi dating from the seventeenth century. Then there are a number of outstanding examples by Takuan, teacher of the Tokugawa shoguns and the Yagyu swordsmen. For the rest of the Edo period, budo masters produced calligraphy and paintings on a modest scale; not a lot of examples remain. However, beginning with Motsugai, who lived at the end of the Edo period, there was an explosion of calligraphy and painting by budo masters as a teaching vehicle and to raise money to fund various charitable causes.

Nearly all the main players involved in the Meiji Restoration had forged their spirit through budo training, initially on the battlefield and then on a more constructive level, and took a nonlethal approach to building the character of the nation's new citizens. There was a regression to the old bloodthirsty military tactics during the fascist period from 1920 to 1945. Not surprisingly, the brushwork produced in this period was bombastic, overwrought, and, ironically, "weak." Virtually no first-rate pieces were created. However, in the aftermath of war, the concept of budo as a "way of peace" emerged, promoted by Kano Jigoro, the founder of judo; Ueshiba Morihei, the founder of aikido; the philosopher activist Nakamura Tempu; and such swordsmen as Nakayama Hakudo. The emphasis was

not on "victory" but "liberation"; a contest was meant to develop one's own character as well as assisting one's partner in developing his or her own. The ideal was "acting in harmony, we reach the goal together."

This book is divided into three periods: Edo (1603–1868), Meiji (1868–1912), and Modern (1912–). The last two periods have the most examples represented. Tesshu has by far the most examples since he brushed by far the most pieces—a million by careful count. (His disciples recorded the exact number of sheets Tesshu produced in each daily session; the average was five hundred sheets a day over a ten-year period.) Thus, Tesshu has a separate section. Alas, there are only three examples of female budo masters: Otagaki Rengetsu, perhaps the most accomplished martial artist; Okuhara Seiko, tough as nails and a famous painter; and Yamaoka Matsuko, Tesshu's daughter, spirited sword fighter, and talented with a brush. In the majority of historical chronicles, the essential role that women played in battle (or keeping the peace) is largely ignored or woefully undervalued. However, on the positive side, there are hundreds of woodblock prints depicting heroic women, and not only from the samurai class—for example, there are a number of scenes of farm girls thrashing would be molesters. In addition to woodblock prints, there are kabuki plays, songs, and, in modern times, movies and TV programs starring strong women warriors. (Recently, scientific analysis of bones uncovered on major battlefields all over the country revealed that at least 30 percent of the bones were from female combatants. The vital contribution of women warriors [onna-musha] in Japanese culture is now widely recognized.)

Nonetheless, brushwork by female budo masters that survived is rare; try as I might, I could come up with only a few suitable examples for publication, and that is because all three female warriors represented here were prolific artists. However, further research will surely uncover more examples of brushwork by female budo masters.

This book is not an art history survey; it is a meditation manual. The illustrations are to be contemplated, not analyzed. It is an encounter between the viewer and the viewed. Everyone sees the artwork from a different perspective. The captions are "hints"; the interpretations are up to the reader.

PART ONE

EDO

BODHIDHARMA

[seal]

Niten

Niten, "Two heavens" (二天), is Musashi's sobriquet.

In 2007, an exhibition titled *Samurai* was held at the Asian Art Museum in San Francisco. I had the precious opportunity to square off against this icon of martial artist brushwork by Miyamoto Musashi. In Japanese, the painting is known as *Shomen Daruma* (正面達磨), "True Face Daruma," that is, "directly in front." The gallery was not crowded, so I was able to assume a position before the painting with about a six-foot *maai*, the "combative distance" between two swordsmen.

I had a meeting of eyes with this Bodhidharma. The Patriarch's gaze was penetrating, but it was not the lethal stare of a wild animal stalking its prey. Rather it was *happo nirami* (八方睨み), "a sharp look in all eight directions." There was no hint of aggression; it was more, "Don't even think of attacking me." Bodhidharma's countenance was severe but not grim. The brushwork was calm and settled, free of any *suki*, "opening," in the composition. The lines of his robe were bold and confident. The painting seemed to be animate. In a real sense, I was encountering Musashi himself in the brushwork. It is one of the highlights of my life.

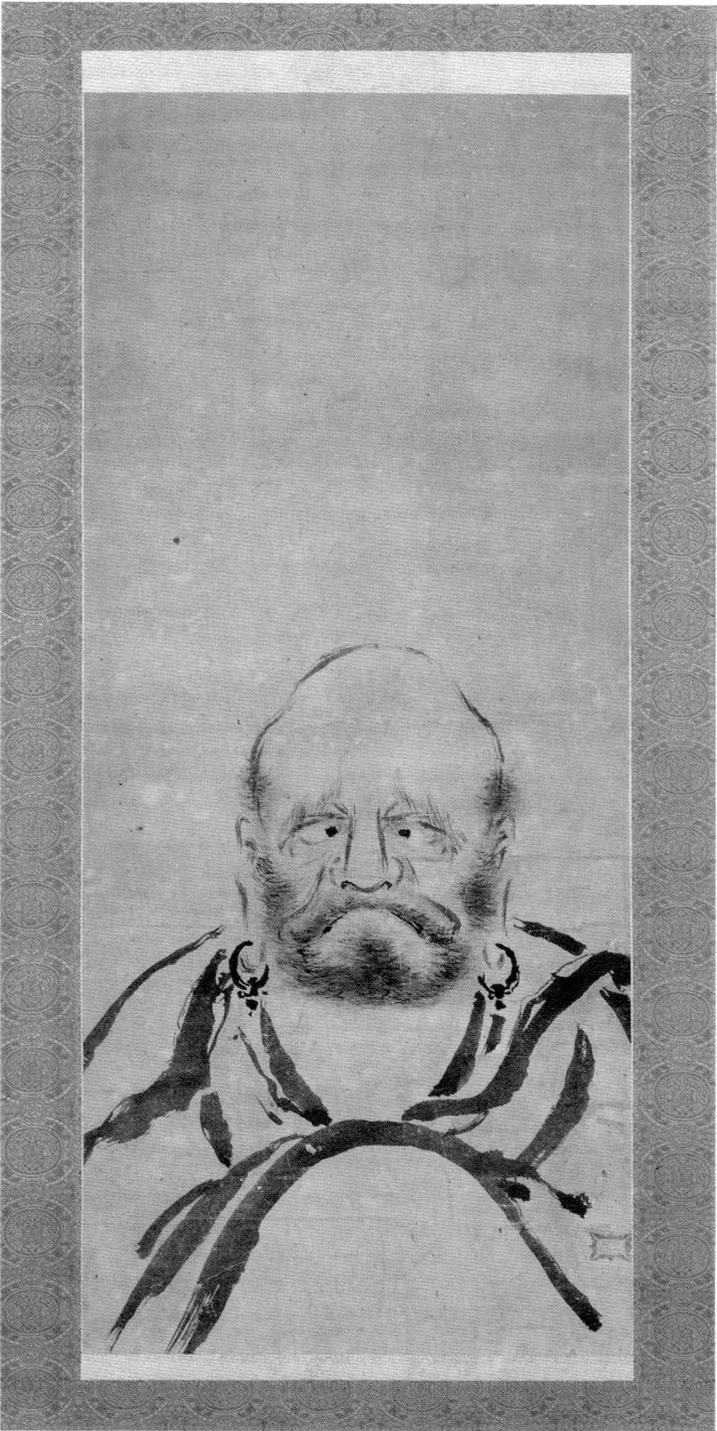

CALLIGRAPHY

Direct pointing to the human heart.
Musashi brushed [this] [seal]

This is the third of the Four Verses of Bodhidharma:

> Not standing on words or letters,
> Outside the doctrine a separate transmission.
> Direct pointing to the human heart (直指人心)
> See into your nature become Buddha.

Since Zen does "not stand on words or letters," Zen calligraphy often consists of a few characters of the most elementary form, as we see here. The previous illustration depicted Bodhidharma as an image; this is a depiction of Bodhidharma as a phrase. In Buddhist iconography, the progression is from realistic, three-dimensional images to two-dimensional paintings to calligraphic representations. Statues are the most concrete, paintings are more interpretive, and calligraphy of words or phrases is the most abstract. But the latter is considered best because the viewer is liberated from looking at outward attributes. The image of contemplation is "conjured up" in one's mind. That is one of the meanings of "direct pointing to the human heart."

The spacing and placement of the four characters are unorthodox but clearly martial; the brushwork seems to glide across the paper. Again, there is no suki in the composition and also no tension.

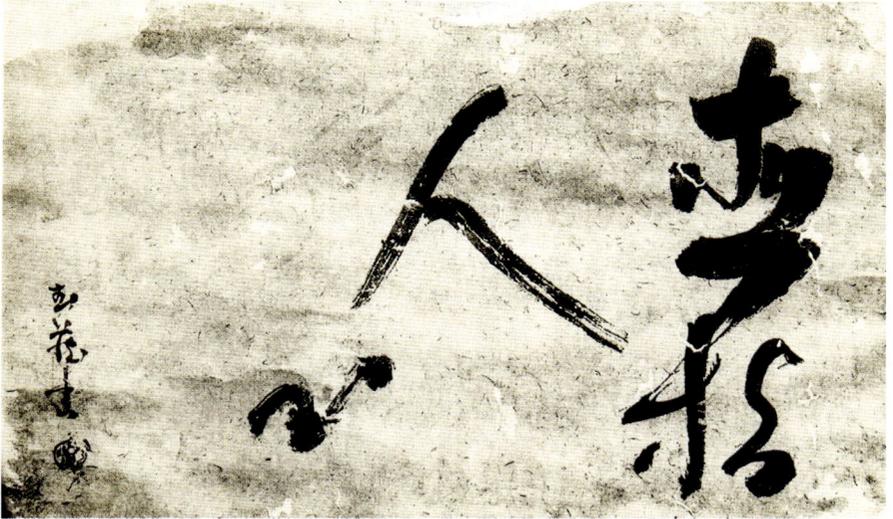

MYOGO

Hail to the great strength, effort, and fierce Buddha!

Shosan

Suzuki Shosan was another battle-hardened warrior. He served with distinction under the Shogun Tokugawa Ieyasu at the Battle of Sekigahara and the Battle of Osaka. At the age of forty-two, however, he resigned his commission and became a Zen monk. He trained as a monk as intensely as if he were still a warrior. His practice is best described as Nio Zen. (Nio are the two fierce guardian statues placed at the entrance to a temple.) Nio Zen is a full-spirited assault on the problems of life with the ferocity of a samurai attack. Shosan's Zen was hard headed, practical, and no-nonsense. Shosan downplayed the distinction between priest and layman, and taught that true enlightenment can only be realized in the midst of daily life— while tilling fields, working as a merchant, or engaging in battle.

There are few extant calligraphic works by Shosan. This is the best-known example. It is a *myogo*, a calligraphic talisman. The meaning is: "Honor [and become a] Buddha by employing all your strength, effort, and diligence!" The brushwork is solid, demanding, and a bit "chill." The entire piece seems to form a staff ready to lower the boom on an inattentive student.

南無大強精進勇猛佛

正三書

ENSO

Buddha Dharma is like the moon [reflected] upon the water.
Takuan brushed [this]

East and West, an *enso* (circle) can symbolize: everything, nothing, infinity, eternity, perfection, sun, moon, mind, heart, center, zero, on and on.

In Buddhism, enlightenment is compared to a "bright full moon." Existence is described as "a circle-like space, lacking nothing, nothing in excess." Many budo transmission scrolls include an enso to represent the essence of technical and psychological mastery—"a bright mirror that reflects all that passes before it and then lets the image drift away without a trace."

The enso is brushed first and then an inscription is typically added. An inscription serves as a "hint" to the meaning and significance of that particular enso. The inscriptions, too, have many variations. They can be puzzling, profound, witty, whimsical, humorous—sometimes all at the same time!

In this case, the thin enso represents the moon. The inscription is one of Takuan's key teachings: *Buddha Dharma is like the moon [reflected] upon the water* (仏法如水中月). Buddhism—indeed any religion—is a magnificent edifice, but essentially it is only a shadow of reality. On the highest levels of understanding, you forget about both Buddha and the Dharma.

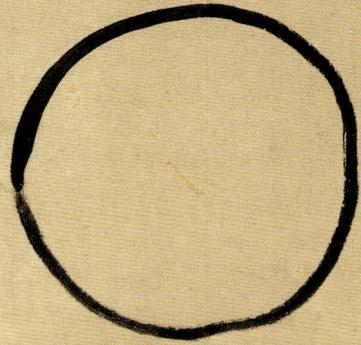

ONE-WORD BARRIER

ONE

After twenty years of wearing out countless straw sandals
What can you say to have gained? This one point!

Takuan, the rustic old monk

A "one-word barrier" is a single character, sometimes standing alone, sometimes accompanied by an inscription as we have here. In both Zen and budo, "simple is best." One word is enough to capture the essence of a teaching. Here, the character (word) *ichi* is a dramatic splash of ink rather than the customary single horizontal stroke. "Twenty years of wearing out countless straw sandals" means to travel widely, internally and externally, for years and years to attain the one truth. Takuan wrote, "As you practice over the days, months, and years, you finally arrive at the point where you are not conscious of your stance nor hold of anything. . . . You are back at the beginning where you knew nothing" (*Fudochi Shinmyo Roku*).

The brushwork is unpretentious, composed in a natural rhythm; the sentiment expressed is encouraging, reassuring: "Sooner or later you will make it." This is an outstanding work of art from any standpoint.

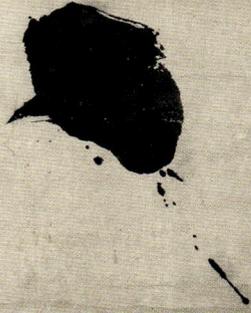

二十年来徒

踏破草鞋に好

何平日一点

愚庵野老

ONE-WORD BARRIER

SEE

[Composed in] Murasaki village, overrun with kudzu grass,
 by Takuan [kao]

This is another example of a one-word barrier. The character 見 is one of the first learned in Japanese primary school. It means "see" and "look." It retains its pictographic form—an eye on legs. Although the concept of "see" seems simple, we know that act to be physiologically and psychologically multifaceted. A *kao* is a stylized signature used in lieu of a seal.

The accompanying inscription by Tenyu (not shown) challenges us:

To see, to not see—
What is to truly see?

THREE-CHARACTER CALLIGRAPHY

Body-within-mystery
(Tai chu gen)
The old fellow Takuan brushed [this]

Tai chu gen (體中玄) has many possible meanings. *Tai* is "body," both the physical body and a person's mental and spiritual makeup. *Chu* is "middle," "within," and "center." *Gen* connotes "mystery," "profundity," "essence," and "fundamental." On an individual level, the phrase can be taken to mean "the mysteries hidden deep within this very body." On a universal level, it can mean "the essence of life pervades the body of existence."

戲中玄

ONE-LINE CALLIGRAPHY

Deeper
Deeper
Deeper!
Silent,
Silent!

The old fellow Takuan

Ichigyo-sho, one line of calligraphy consisting of a poetic phrase or a philosophical aphorism of three to ten characters brushed vertically, are a staple of Zen calligraphy, especially by Daitoku-ji abbots such as Takuan. The brushwork displayed in this one-liner is dramatic, bold, and dynamic. The composition of the piece is especially creative; the vibrant characters appear to be cascading down the paper.

Even though there are only three kanji involved, there is a wealth of meaning present with countless possibilities for interpretation. *Gen* (玄), the first character, means "fundamental principle," "deepest mysteries," and "hidden meaning." *Do* (々) is the symbol for "ditto." *Moku* (黙) is the character for "silence," "beyond words," "say no more," "speechless," and "shut up."

玄ゝに戦一

澤庵筆

ONE-LINE CALLIGRAPHY

Autumn moon [is] bright.

Takuan, the old fellow

This is a line from a poem by Li Po:

> The autumn wind is cool,
> The autumn moon is bright (秋月明).
> Fallen leaves pile up and then scatter.
> Startled ravens take to flight.
> Where are you, my beloved—when shall we meet?
> At this hour, how my heart aches.

In Zen calligraphy, the simplest, most basic characters can manifest the deepest truths. What is more perfect and beautiful than the bright autumn moon?

秋月明

澤庵叟

THE ONE TRUE TASTE OF TEA

I share a sip of tea together with the spring wind and ten thousand peaks;
Then with my arms folded in my sleeves I contently stroll along the
 riverbank.

[Ri]kyu Koji [Buddhist Lay Practitioner]
Soeki (kao)
[Message to] Kanbayashi Kyukai the Elder

The verses evoke a tranquil state where there is no sense of separation
between humans and nature. One feels that the universe itself is being
sipped and savored. The brushwork is extraordinarily supple and perfectly
composed and placed. The rhythmic calligraphy is clear and bright, calm
and settled.

The Kanbayashi family is one of the major tea growers and merchants
in Uji. The Kanbayashi Shunsho Honten tea business was established in
the 1560s. Rikyu had close ties to this family. He regularly ordered matcha
tea from the store, and several members of the family were among Rikyu's
senior disciples. One of Rikyu's daughters married into the Kanbayashi
family, whose archives contain a number of letters from Rikyu concerning
orders for tea, delivery receipts, and as in this case, replies to questions
pertaining to the true nature of tea. This letter is Rikyu's response to Kan-
bayashi Kyukai's request for a statement on the essence of the tea ceremony.

One of the most well-known anecdotes in tea circles tells of when Rikyu
and a few disciples were hosted by Kanbayashi Chiku-an in Uji. Flus-
tered by his master's presence, Chiku-an made several clumsy mistakes
and flubbed the ceremony. Nonetheless, Rikyu complimented Chiku-an
on his fine performance: "No one could have done it better." On the way
back to Kyoto, Rikyu's puzzled disciples asked how he could praise such
a sloppy execution of the ceremony. Rikyu replied, "Heartfelt sincerity
trumps technique."

一啜一面
茅岳青風一
啜洪自舞双
袖水色折
伏巖士
上林伴涛老人

ONE
(Ichi)
China Son brushed [this]

This single stroke is a masterpiece of brushwork, as relevant for contemporary art as it was in the classical age centuries ago. Nothing could be simpler or more profound.

Jozan modeled his life after a Daoist immortal, considering himself a child of Chinese culture. The calligraphy is a variation of the distinctive clerical style script that he perfected. Jozan, originally a fierce samurai warrior, is revered as one of Japan's greatest calligraphers.

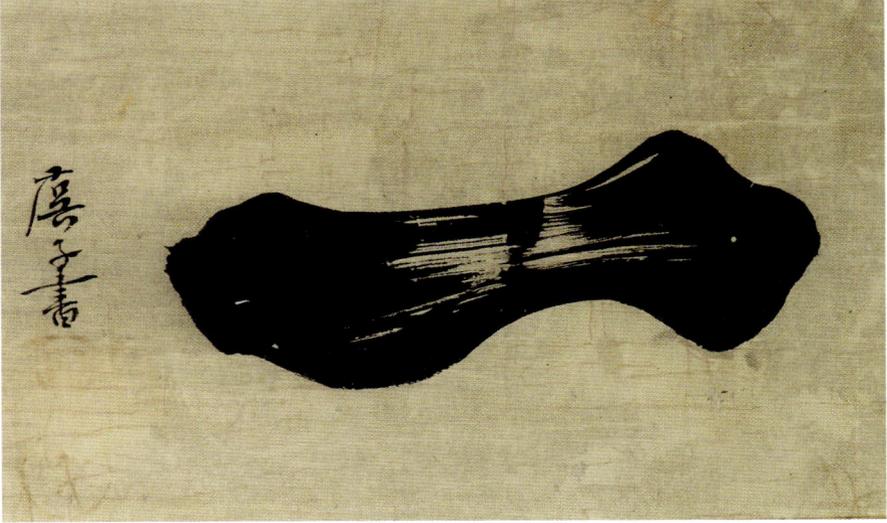

ONE-LINE CALLIGRAPHY

One Thought Three Thousand

One Thought Three Thousand (一念三千) is the pillar of Tendai and Zen Buddhist philosophy. *Nen* means "thought" in the sense of how insight or perception manifest, mentally and physically, in one's being. A single profound, awakened thought allows one to perceive and experience all three thousand realms of existence past, present, and future. Such a vision encompasses everything, from the tiniest atoms to the largest galaxies.

Another interpretation is that in each thought, there are three levels: empty, provisional, and middle. Each level has a thousand dimensions, making three thousand that are linked together in one instant of thought. The brushwork in this piece is extraordinary—bold, creative, and dynamic. When this piece was exhibited in a museum setting, it seemed to take over the room. The collector remarked that this scroll became the "boss" of his entire house.

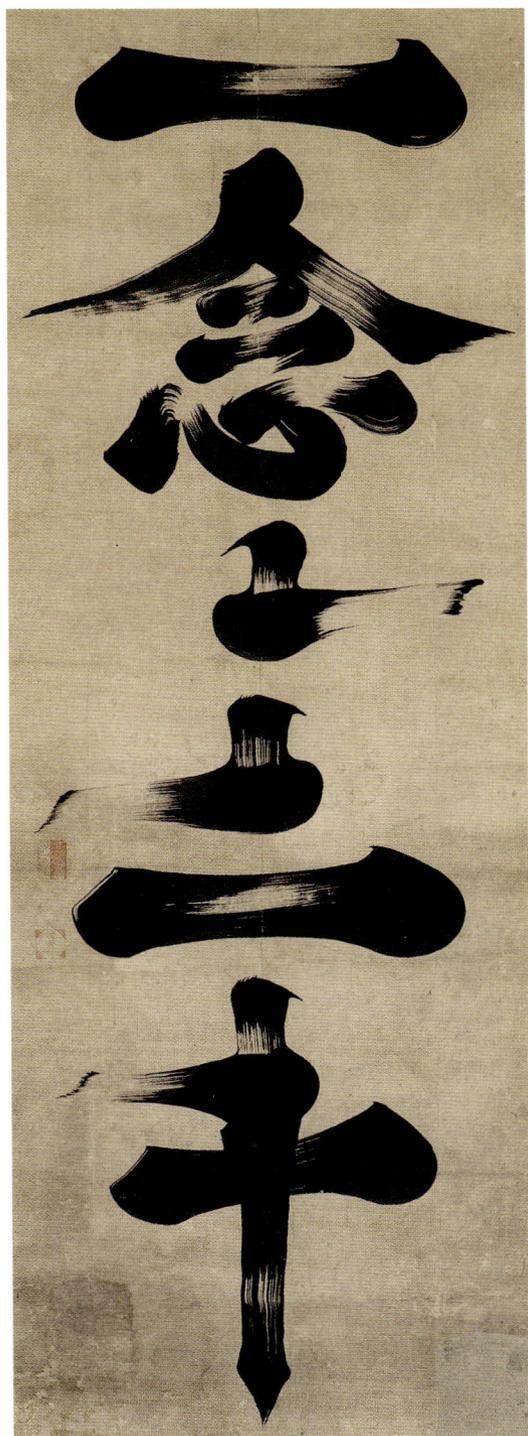

一念三千

HAIKU

New Year's Day:
Now I long to see
The sun over Tagoto.
Basho

This haiku

Ganjitsu wa
tagoto no hi koso
koishi kere

was composed on New Year's Day 1689, when Basho was forty-six years old, at his residence in Iga-Ueno. The autumn before, Basho had made a journey to Mount Ubasute. At the base of the mountain, there are many small rice paddies, *tagoto* in Japanese. Basho had long wanted to witness the autumn moon over the tagoto. After a difficult journey, Basho was rewarded with the view of his dreams. When Basho saw the sun rising on New Year's Day in Iga-Ueno, ascending over the decorative New Year pine branches, it brought back fond memories of the moon's reflection on the wet rice fields, but this time it was the sun shining on dry fields.

元日見

日

MYOGO

Dai

Sei

Fudo

Myo

O

This is a *myogo* for Fudo Myo-o (大聖不動明王), the patron of Japanese martial artists, by Hakuin. (His seals, barely perceptible, are on the lower right side.) The bold brushwork is majestic, radiating with a quiet power. The "Hakuin drip" from the top character *dai* (大) is an added bonus. Hakuin had many samurai disciples who were keen devotees of Fudo. Due to their intense mind training, awareness of whatever situation they found themselves in, and their ability to gauge human behavior, many Zen masters were also skilled martial artists. (A number of them actually were samurai warriors before their ordination.) As mentioned in the introduction, while such masters were strictly bound by the precepts not to hold a bladed weapon, there are countless tales of Zen masters disarming an enraged attacker, typically by staring him down or easily avoiding a thrust or cut.

Since Hara, where Hakuin lived, was a rest stop on the Tokaido, provincial lords lodging there would seek Hakuin's counsel. The perceptive Hakuin would sometimes berate a lord for his bad behavior back home that would cause his domain to fall into ruin. One lord—not accustomed to being criticized by anyone—took umbrage and drew his sword, intending to cut down the insolent monk. Hakuin deftly dodged the attacks until the enraged lord was exhausted. The ashamed lord calmed down and apologized for his behavior, promising to take Hakuin's words to heart and change his ways.

大聖不動明王

MARTIAL ARTIST ROOSTER (DETAIL)

Many samurai artists were fond of painting birds. The majority of Musashi's paintings were of birds; other artists painted hawks. Ito Jakuchu, the eccentric greengrocer artist, specialized in roosters. While most of his depictions of roosters were whimsical, occasionally he painted a "martial artist rooster" such as this one. The rooster has a sharp, penetrating gaze—likely locked in on another rooster—and is in the *hanmi* stance of a swordsman. The rooster's body bristles with energy.

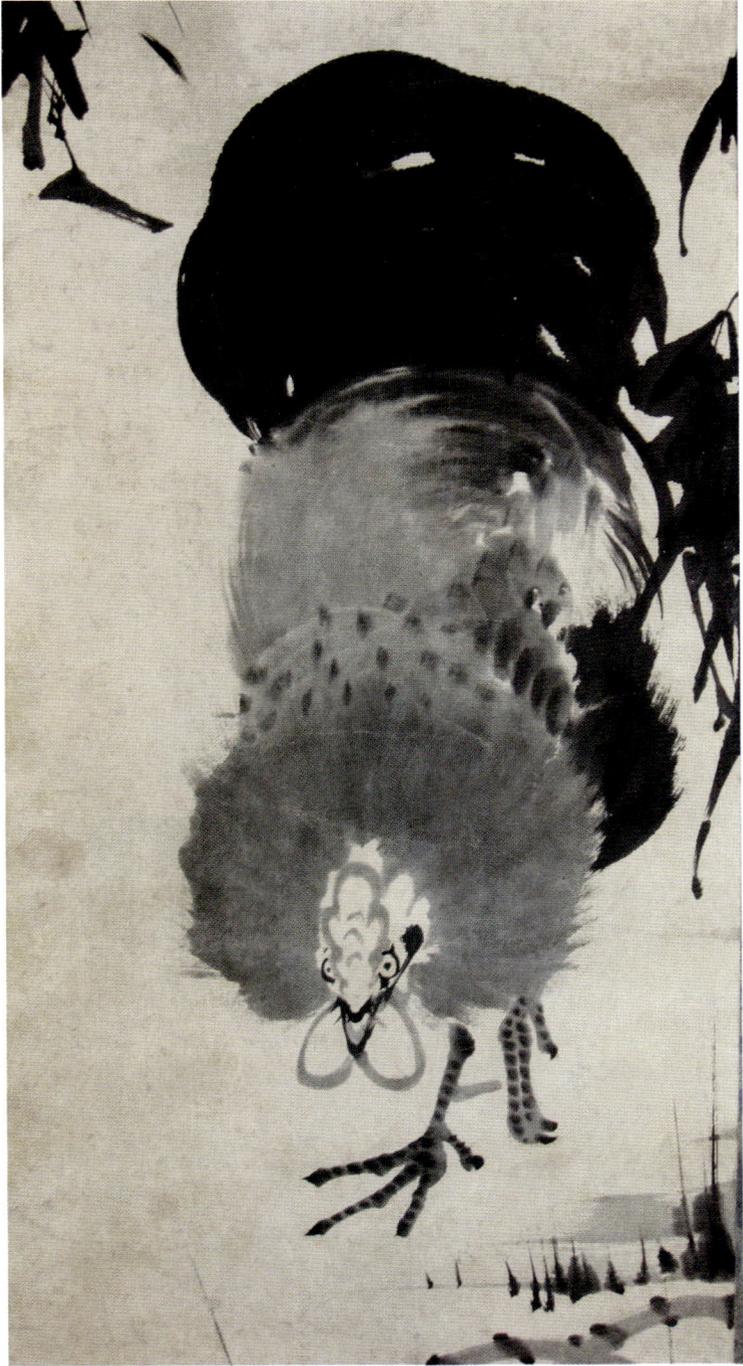

Inscription [Not shown.]

KILLER FROG (DETAIL)

The painting is by Sengai, with an accompanying inscription by an unknown calligrapher.

> The two square off for a fight to the death
> The one who is not rash,
> Who takes a breath [has the right timing] will win—
> In the evening cool.

Usually this type of encounter—which often takes place in the evening—ends badly for the frog, but this time my money is on the amphibian. The thin, timid-looking snake appears woefully overmatched. The frog is in a sumo stance (*tachi-ai*); in sumo, timing is key to victory. Sengai's Zen frogs are typically whimsical creatures, but this killer frog is fierce. Like Hakuin, Sengai had many samurai swordsmen disciples.

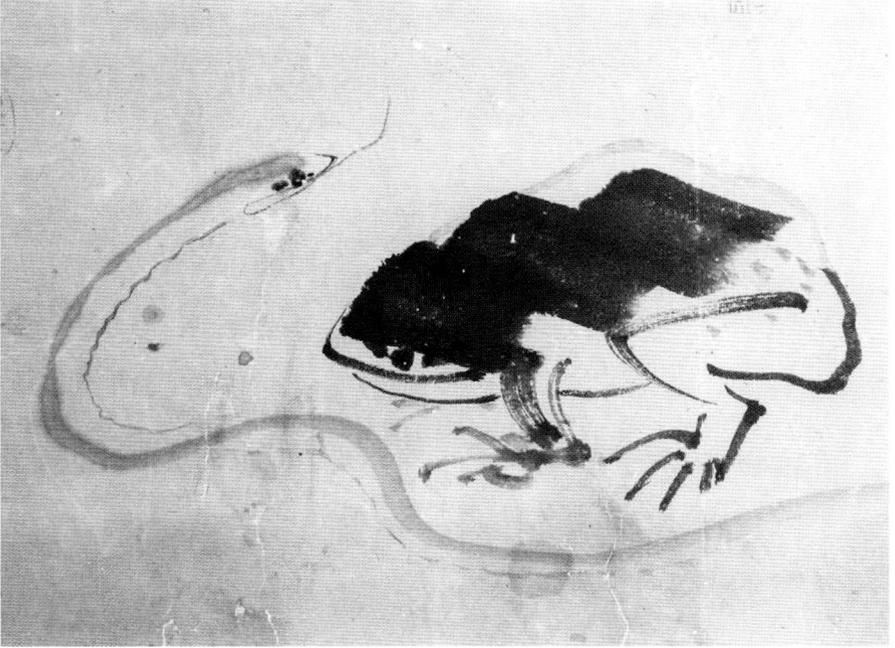

SKULL

Samurai don't dream they are always sincere!
Undo shinjin

This means that a true samurai is not a dreamer but a realist. Since we all end up like this skull, we should act accordingly, not shirking our responsibilites and wasting time on frivolous pursuits.

Shiryu's unusual calligraphy was an extension of his budo practice; he let out a terrific shout just before picking up the brush and sprayed the room with ink when he wrote. His brushwork is no-nonsense, devoid of flourishes.

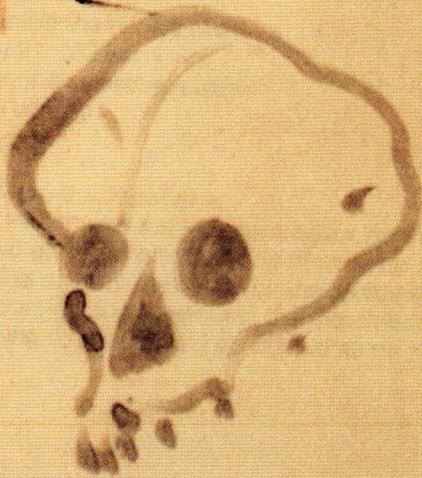

志士不忘在溝壑

遷寺門一狂人

TRANSMISSION SCROLL

Ito Ryu Strategy Special Transmission
Tenshinden Heiho Catalog of Techniques
Illuminating the Way Principles
[signature not shown] Shirai Toru (kao)

[Translation] Swordsmen of Tenshinden strategy must illumine, in a flash, the technique of life and death on the battlefield, master how to advance and retreat, gauge one's environment, and respond in a vigorous manner. Smash the aggression of an attacker by breaking his anger and resentment. Victory will be accomplished naturally by learning the subtle mind principles of Tenshin. Those with self-confidence make those principles the backbone of all strategy. If you want to turn defeat into victory, rely on a focused fighting spirit. Learn about the mysteries of the body, and study the principles of the mind. That is the key to mastering the state of "Innate-True Emptiness-No Form-Marvelous Mind" . . .

The brushwork here is measured, no nonsense, and solid. No unnecessary flourishes, idiosyncratic calligraphy, or straying from the classical forms. It is the brushwork of one who is supremely self-confident.

一刀流兵法別傳

天真傳兵法目錄

明道論

天真傳兵法者士株兵臨戰爭

明生死之術也故進退周旋不

活潑自在何得碎堅甲折利兵

忽散忽怒以全其勝邪雖然學

之者不知通天真微妙之心理

故執著於有而事贅刀振兵欲

去敗求勝爭氣專之則雖終身

学之何得其妙邪亦学之者聞

於性中真空無相妙法執著於

DARUMA

Daruma came to the West with a mouth but no tongue.
Motsugai

Along the same lines as Musashi's portrayal of the First Patriarch, this is an "in-your-face" Daruma by Motsugai, one of the physically strongest martial artists of all time. The expression of Motsugai's Daruma is much more severe and mesmerizingly powerful; in contrast, the brushwork of the inscription is lively and bright. The inscription is a humorous Zen riddle; paired with the deadly serious expression of the First Patriarch, it gives the *zenga* a nice balance.

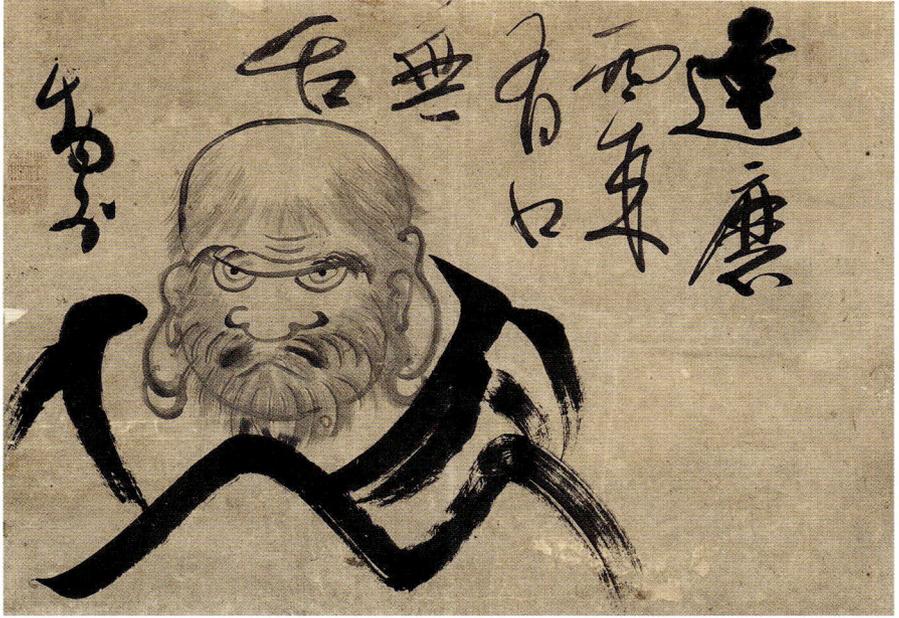

MOUNT FUJI

Above the white clouds
Nothing—
Fuji no yama.
Motsugai

Usually, Motsugai gives the characters for Fuji as 不二, meaning "no dual-ity" between the Buddha-nature of Mount Fuji and the Buddha-nature of the individual—and there is "nothing" between them. In the case of budo, it signifies that there is no separation between two opponents; an enemy is not seen as an "other." The enemy is actually an extension of "self." Here, however, Fuji is given as 不尽, "not exhaustible." In nonduality, since nothing has a beginning or an end, it can never run out.

There seems to be a break in the right slope brushstroke, but upon close examination, the stroke is there, subtly connecting the darker line.

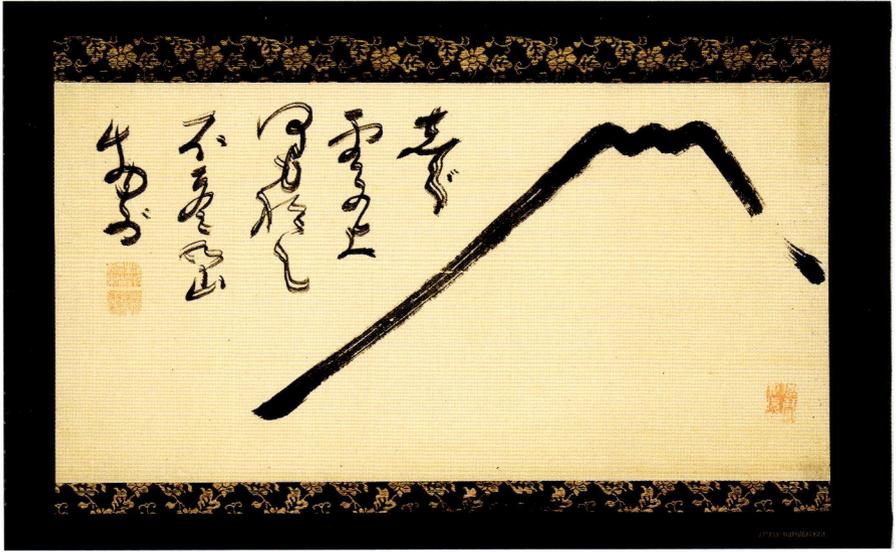

ENSO

Everywhere those in the know enter
This religion.

Motsugai

The last character, *shu* (宗), means "teaching," "belief," or "religion." In this case, the enso symbolizes *shunyata*, the "emptiness" that Buddhists believe creates and sustains the universe. To enter "this religion" means to comprehend emptiness and attain awakening. The placement of the enso at the bottom of the paper creates a sense of having to bore, to dig deeply, into the center of the circle to find its core.

十方知者入
諸安宗

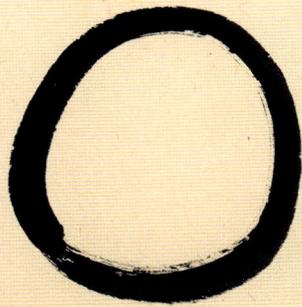

DEMON ROD

One who causes a cart to end up in a ditch [= an unprincipled troublemaker] will get to see this!

Seventy-year Motsugai stained [painted this]

Japanese demons (*oni*) wield iron rods to beat evildoers as they fall into hell. Demon rod zenga typically have an admonition such as this. This substantial staff looks heavy. As a martial artist, Motsugai used an iron rod similar to this for training.

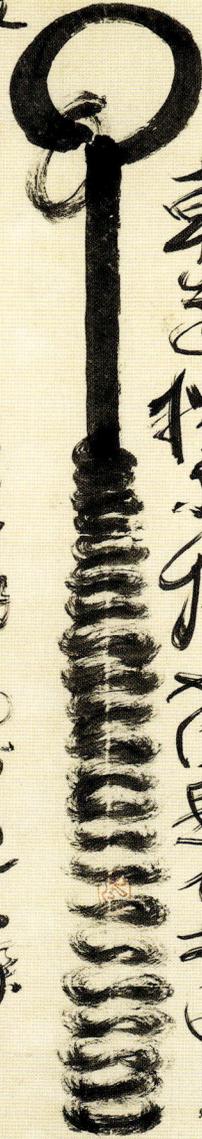

救

事を修行者に任せておけ

七十翁白隠叟書

ZAZEN ONI

Let go of
Everything
You don't have,
Forget everything you don't know,
And just be like this [= Buddha]!

Inscription by Motsugai

Even demons can be transformed through Zen meditation; an oni's bravery and fearlessness can make its enlightenment more powerful and effective. The oni has placed its rod on the ground in front of it; it no longer needs the rod to smite evildoers. The inscription is a koan—"How is it possible to give up what we don't have and forget what we don't know?"—to be pondered single-mindedly and intently like the fiercest demon.

Although Motsugai was famed for his unequaled physical strength and his martial arts prowess, his zenga have a light, humorous touch, much like those of the other great martial arts master Tesshu. Motsugai and Tesshu were nicknamed Demon, but they both display a wonderful sense of joy and freedom in their zenga—not all hard-edged and grim, as we might expect from a demon.

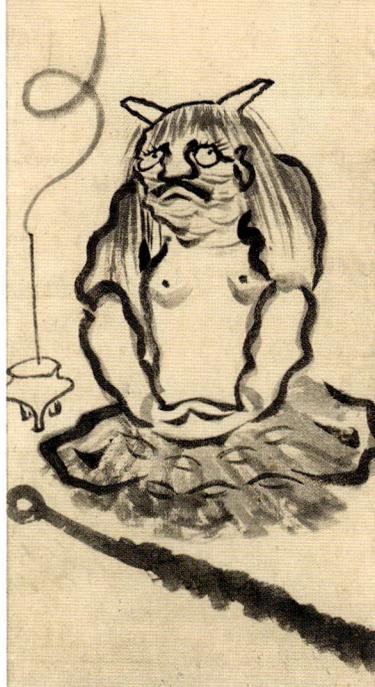

ONE-LINE CALLIGRAPHY

A good thing is not as good as nothing!
Muddy Buddha Hermit Motsugai the old monk brushed [this]

This phrase occurs in case eighty-six of the *Blue Cliff Record*, and number 513 in *The Records of Joshu*. The case involving Joshu goes:

> As the master was leaving the hall, a monk bowed to him.
> The master struck him with his staff.
> The monk said, "But bowing is a good thing!"
> The master replied, "A good thing is not as good as no thing."

When there are things we like, we want to have more; the more we crave good things, the more we want to avoid bad things, and that upsets life's applecart. Life is a mixture of good and bad things. Attachment to anything, good or bad, will harm us.

好事不如無

GO BOARD

Good Fortune Like a Magic Jewel
Sealed with a fist [knuckle marks]
Motsugai

A "Magic Jewel" is the equivalent of Aladdin's lamp. Another of Motsugai's nicknames was Monk Fist because of his ability to leave knuckle marks on a thick go board. It was his trademark.

福壽 如意

印拳漆

物外

MAXIM

The sword is the mind;
If the mind is not true
The sword will not be true;
One who wants to study the sword
Must study the mind.

Tenpo ju nen [1839] Spring
Shimada Toranosuke

This is one of the most widely quoted maxims among kendo practitioners; entire books have been written on the subject that offer guidelines, but true understanding comes through experience.

剣は心なり
心正しからざれば
剣又正しからず

剣を学ばんと
欲すれば
先づ心より
学ぶべし

昭和拾八日春
島田虎之助

PART TWO

...

MEIJI

TANZAKU

Mountain Hut
Living deep in the mountains
I have grown fond of the sound of murmuring pines;
On a day the wind does not blow, how lonely it is!

Eighty-three Rengetsu

When I first saw Rengetsu's calligraphy, I recognized immediately that she was a martial artist because of the precise spacing between the characters and between the rows. Furthermore, her calligraphy displays no break in concentration, no wavering of line, and no slack from start to finish. Large or small, the characters retain their proportion. Rengetsu's martial arts training taught her how to maintain the proper balance between the characters so they would be linked and flow together. Rengetsu's characters are sharp and powerfully executed. Rengetsu's poetry is a *waka* consisting of syllables in a 5-7-5-7-7 pattern. In this case:

Yamazato wa
matsu no koe nomi
kikinarete
kaze fukuna hi wa
sabushi kari keri

こひ

とこはものなのときをあれて
いぶ　むぜふしみかさふしうらく

AUTUMN MOON

In the fields, in the mountains
I was enthralled, so enthralled;
On the way back home
The autumn moon accompanied me
All the way to my bedroom!

Rengetsu

Here is an example of a Rengetsu *gasan*, a painting accompanied by a waka inscription. The brushwork flows down the paper seemingly following Rengetsu. Her little signature is on the very bottom, "back home" so to speak.

つまもなく
うれしくて
うへうさを
ねやまてみる
秋のよる

BAMBOO

Kept in the shade for so long, the bamboo shoots by my window
Now flourish magnificently day by day adding node after node.

Seventy-four-year-old Rengetsu

Japanese artists in general, and budo practitioners in particular, are fond of brushing bamboo—the lovely branches are flexible but unbreakable, even in the strongest storm.

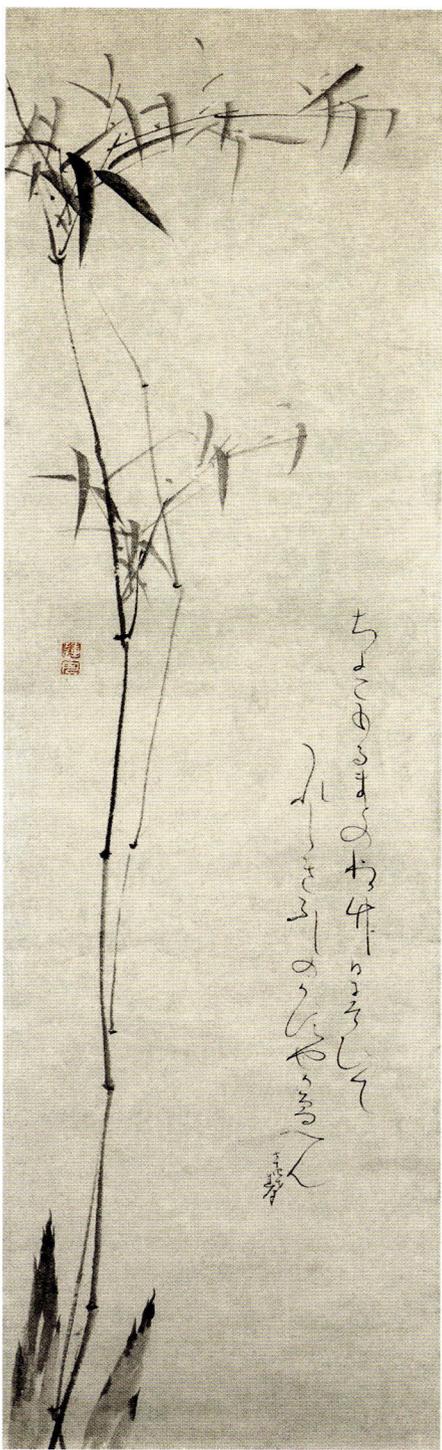

ちよくちるまでのおもいのうきにして
ねてきふしのうやうやるく人
千代萩

WILD GEESE

This fleeting world—
Thinking of its sorrows
Makes me so sad.
Like rain pouring down from heaven
My tears fall and fall.

Rengetsu eighty years

This is a melancholy poem, with the two wild geese and the calligraphy seeming to pour down from heaven in long streams of tears, filling the entire space. The two geese are shaped by little more than a splash of ink.

うのくもをあめし
つらねてちるもれに
あまのちるく

ちるらうこ

うみ

BUTTERFLY

Sporting and sleeping
Amidst the dew in
A field of flowers—
In whose dream
Is this butterfly?

Rengetsu

This refers to the famous dream of Chaung-tzu: "Am I a man dreaming of a butterfly or a butterfly dreaming I am a man?" There are several other meanings. In Japan, it is believed that at the time of a person's death, a butterfly will appear to relatives, friends, and students who are close to the deceased, as a kind of farewell. (In Rengetsu's case, all of her family has departed.) Rengetsu's signature is to the side, as if she is enjoying the butterfly and the calligraphy dancing about. The movements of dancing and the movements of budo have much in common. In her younger years, Rengetsu was known for her ability as a dancer. The work is animated with no sense of a pause or a break in composition.

うれしきて
をよくつる
われしるく
こりし虫よ
六ふるらし

POUNDING A ROBE

When I hear the sound of winter robes being pounded,
The dew on the sleeves scattering about,
I suddenly feel
A touch of melancholy.

Rengetsu

In the clear, cool autumn night under the bright moon, the village ladies pound out the dirt and grime accumulated in thick bolts of cloth, preparing it for winter wear. The mallets are heavy and are swung rhythmically in the manner of a wooden sword, using not only the arm but the entire body. A yearly event held every autumn, paintings of the scene invariably portray the pounder as a pretty young woman. The erotic overtones are clear, and the sound of the rhythmic pounding echoing through the night stimulates all the senses.

こころもうつろきけ
そてのつゆくこけ
もておもくここうれ

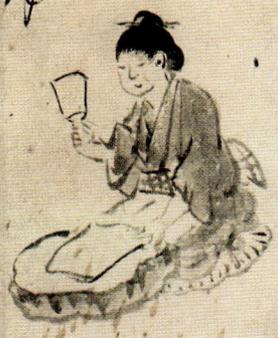

MOUNT FUJI

Kaishu

A zenga Mount Fuji is painted with a minimum of brushstrokes. The simple lines seem to create something—a mountain, the most substantial thing there is—out of nothing. One meaning of *fuji* is "not second; there is nothing equal to it." Another is "not two"; Buddha-nature and human nature are one.

Nonduality applies to male and female as well. From ancient times, Mount Fuji was believed to be the holiest site in Japan and the best place to have sexual intercourse. Caves scattered all over the side of the mountain were used by pilgrims for the sacred worship of sex. In person, Fuji is as erotic as nature can be; there are many poems pleading with her to shed her robe of mist and show her pure white skin. These days, anyone—young or old, male or female, rich or poor—can climb Fuji, on foot or in the mind, and reach the summit. There are many paths to the peak. Mount Fuji can be the Pure Land of Buddha or the Abode of the Shinto Gods.

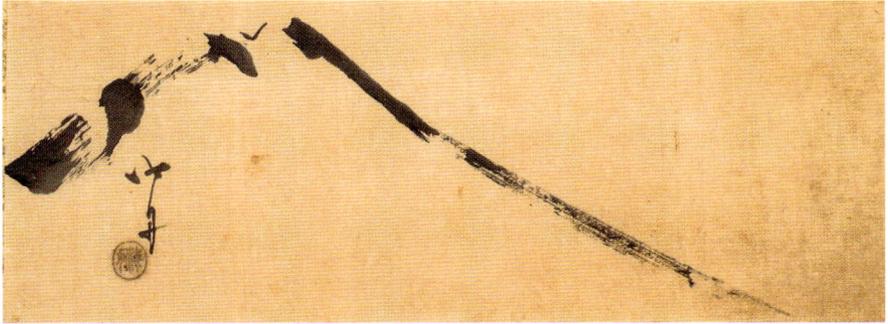

HORIZONTAL CALLIGRAPHY

One who remains calm in nature has longevity and filial children.

Kaishu

This is good commonsense advice for anyone, but Kaishu was noted for giving an added twist to the subject of his calligraphy. One of his favorite sayings was, "Heroes love sex." Most of the samurai leaders who brought about the Meiji Restoration had girlfriends (who they often later married) in the pleasure quarters. Many of the most momentous meetings in modern Japanese history were held in brothels.

The brushwork is playful, even a bit naughty. The first character also means "sex," so the saying could be interpreted, "One who enjoys a steady sex life will stay young a long time and have many good children to care for him in old age." In addition to his wife, Kaishu took in a number of "maids"—there were reportedly seven or eight of them at the time of his death—many of whom bore him children and remained full members of the household.

性静香客寿者

FAN

Green mountains originally don't move;
White clouds of themselves come and go.
Kaishu

This inscription suggests that one's original Buddha-nature cannot be moved from its core; the white clouds of delusion freely arise and dissipate. The calligraphy spans the surface of the fan, placed off-center at precisely the right spacing. Two characters per line is a standard practice for brushwork on a fan.

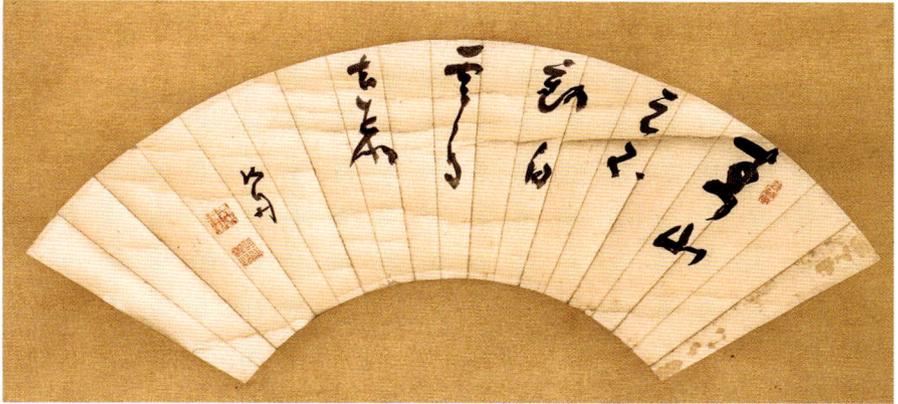

MOUNT FUJI

This mountain is called Fuji (Not Two);
It emerges from the earth to spread across
The entire universe in one unbroken link.

Deishu Sei

Although this huge Fuji, more than six feet wide, is composed of only four connected brushstrokes, it seems to span heaven and earth.

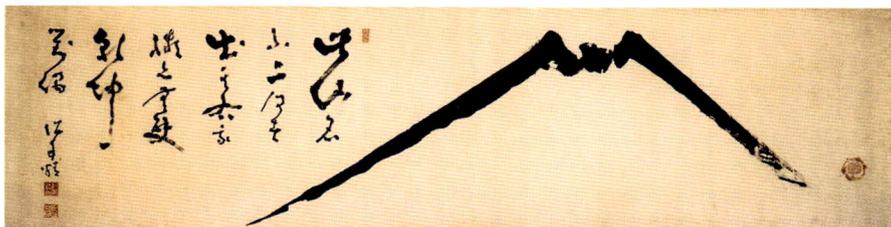

SKULL

One hundred years, ten thousand years—one dream within a [dream] . . .
Deishu Koji

"Life is a dream within a dream" is a well-known saying everywhere. In this case, the second "dream" is replaced by a painting of a skull. Regardless of whether you live for a year or ten thousand years, the end result is this.

From the Buddhist perspective, all things are transient; we are all destined to die. But from the Zen perspective, that is not a bad thing—that's just how it is—so live completely and do not fret about this and that. Zenga skulls are bright and fresh, not at all frightening, full of good Zen humor, and in a sense reassuring.

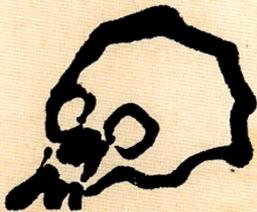

SKULL

If you are not born,
You won't die;
What is this?
You are born to die,
So if you have a body
this is the ultimate result!

Deishu the Eccentric

Here is a Deishu painting of an abandoned skull bleaching in the sun. Such a sight was not uncommon in the turbulent years of the fall of the Shogunate; many solders perished during the fighting and were left to rot on the battlefield. This was brushed later in Deishu's career so the calligraphy is more refined and supple.

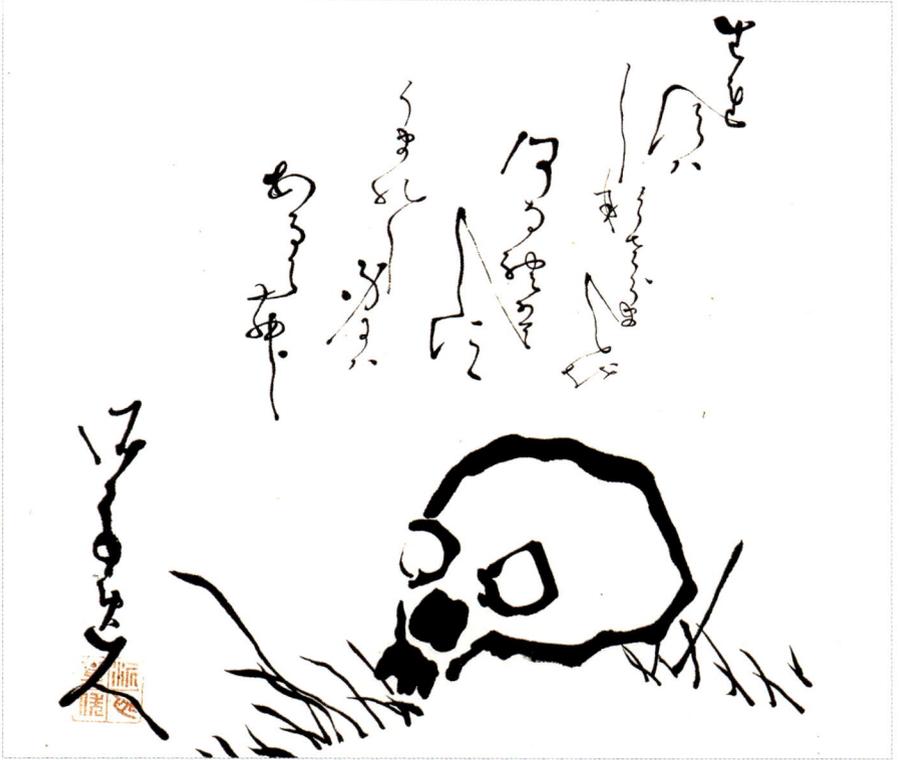

HOTEI

From ancient times, throughout the universe,
His name is known for thousands of years:
[Hotei] revered on earth as a great being.

For Mr. Aramatsu, brushed by the old-fellow Deishu

Hotei is considered to be an incarnation of Miroku (Maitreya), the Buddha of the Future, who is always living among us, so we don't need to wait until he makes his formal appearance millenia from now. Although dressed like a hobo, living free of social constraints, and doing want he wants, Hotei is actually a great bodhisattva, bringing Buddhism down to the marketplace. Deishu's happy-go-lucky Hotei has a big smile on his face, despite his importance of being the future Buddha and the fact that he is doing zazen, usually thought of as a harsh discipline. This zenga shows us that Buddhism is not something abstract and distant; it is right here, manifest in our daily lives. It also shows that serious practice can (and should) be combined with existential good humor.

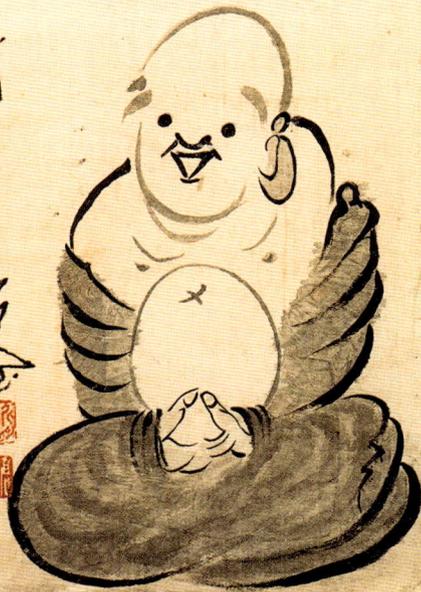

BUSHIDO

Warrior way
Deishu the old man brushed [this]

Bushido (武士道) is a set of values for the warrior. Originally, the *bushi* were fighters on the battlefield, but in more peaceful times, they became warriors of the spirit. The bushi code emphasized justice, courage, benevolence, respect, honor, loyalty, good manners, proper deportment, frugality, and above all, sincerity. Sincerity (誠 *makoto*) is perhaps the most important Japanese value.

The calligraphy itself manifests the elements of bushido—it is calm, vigorous, stately, and sincere. The ink tones are bright. Deishu studied the cursive calligraphy of the eccentric Tang dynasty Chinese monk Huaisu for many years and mastered the art of the spear; both influences can be seen in the brushwork.

KAISHO

Within No-Sword there is Yes-Sword, within Yes-Sword there is
 No-Sword;
If you want to understand the Sword of No and Yes, [contemplate the]
 bright autumn moon high in the sky.

Deishu

Deishu's *kaisho* (standard script) is outstanding, considered among the fin-
est in the history of Japanese calligraphy. While his cursive calligraphy can
be wildly idiosyncratic, his block-style characters adhere strictly to classical
standards, with a more supple touch.

無刀裏有刀有刀裏無刀欲識刀無有秋天朗月高

泥翁

ONE-LINE CALLIGRAPHY

Take care of how you speak and pay strict attention to how you act!
Deishu Koji brushed [this]

This is a quote from the Confucian *Book of Rites*. Much budo calligraphy consists of quotations from the Confucian classics, because the study of the Chinese classics was an essential element of samurai education.

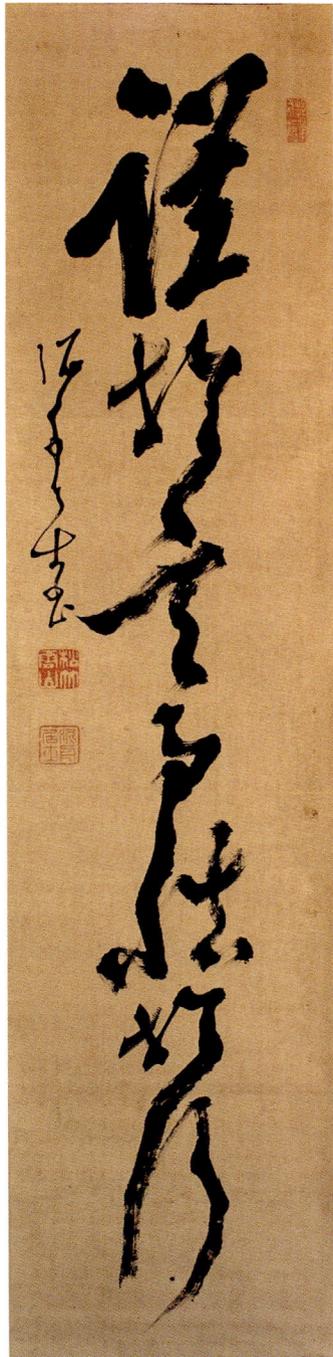

NA-MU MYO-HO REN-GE KYO

Hail to the Lotus of the Good Law
Deishu Koji brushed [this]

Namu Myoho Renge Kyo is the principal chant of the Nichiren school, but Zen masters were not averse to doing myogo calligraphy for Nichiren followers, even though Nichiren himself called the Zen school a "bunch of demons." Deishu was a great Zen layman, but he was also born into a family of Nichiren school believers, so a Namu Myoho Renge Kyo calligraphy by him is not unexpected. In myogo, the brushstrokes themselves are considered to radiate sacred power.

南無妙法蓮華経

TWO-CHARACTER CALLIGRAPHY

Raku Mu

Deishu brushed [this]

In this case, *raku* (楽) means "pleasure," and *mu* (無) is "disappear." There is a saying, "Pleasure is the seed of pain; pain is the seed of pleasure." One meaning of the calligraphy is "Pleasure sooner or later disappears, so don't get attached to it." Another meaning is "Delight in Mu!" Mu is the most difficult and liberating Zen koan. When this barrier is broken, through, it is the key to Zen bliss.

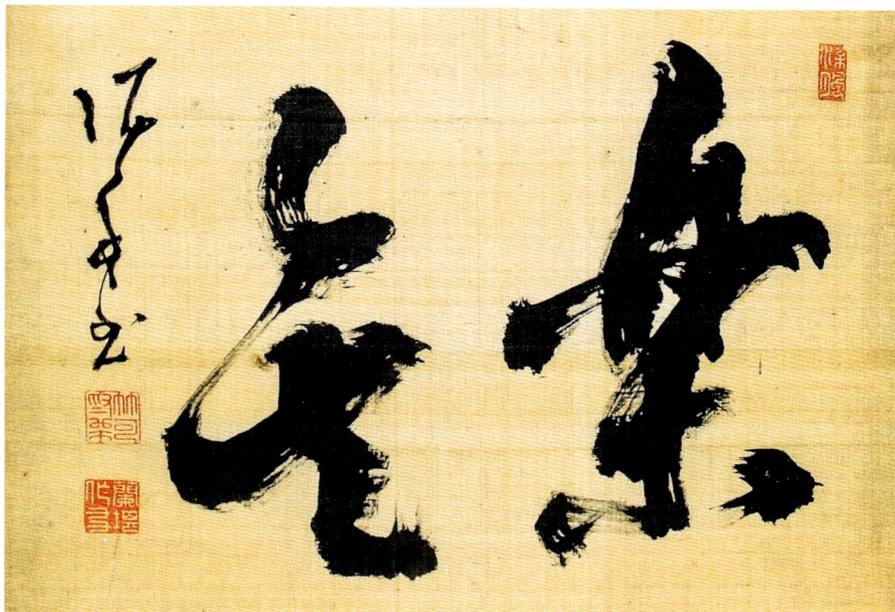

HORIZONTAL CALLIGRAPHY

Wind Flowers Snow Moon
For Mr. Asami
The eccentric Deishu brushed [this]

Wind 風 (summer); flowers 花 (spring); snow 雪 (winter); and moon 月 (autumn.)

Each season has its joys (and sorrows) and distinctive ambiance—in poetry, song, food, and dance.

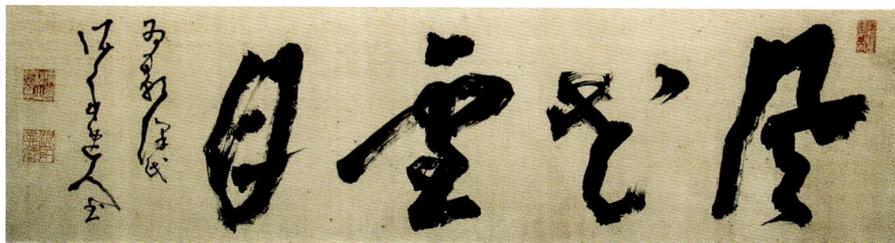

屋已室日

WAKA

Many hardships
Are given to us in life
But if we learn from them
We will grow straight and strong
As the sturdy bamboo planted in the garden.

Deishu

Despite the heavy snow and fierce winds they must endure, the strong yet flexible bamboo that are planted in a garden—that is, to be cultivated rather than left to run wild—continue to put forth new shoots, eventually growing straight and tall. Human beings are the same; if we learn from our hardships, we will eventually flourish.

This calligraphy is at the opposite end of the spectrum of Deishu's brushwork. Although it appears to be completely irregular and undecipherable, it is actually legible once you become accustomed to Deishu's unique interpretation of the characters.

WAKA

At Natsumi River
Night lingers
Into the dawn . . .
From the bank
A water rail cries.
Deishu

This is another example of Deishu's mastery of the brush, displaying perfect control and spacing. The brushwork itself flows down like a river. It is quite similar to the calligraphy of Rengetsu, whom Deishu knew and admired.

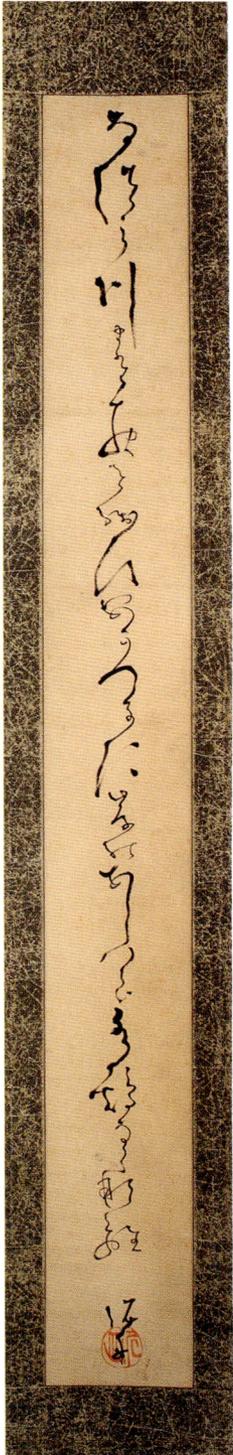

HORIZONTAL CALLIGRAPHY

Revere Heaven, Love Mankind.

Nanshu brushed [this]

"Revere Heaven, Love Mankind" (*Keiten Aijin* 敬天愛人) was Saigo's favorite maxim. *Keiten* means "revere and hold in awe"; *aijin* is "love mankind" in general but "love thy neighbor" on a more personal level. (*Nanshu* 南洲 is Saigo's sobriquet.) The best way to honor heaven is to love fellow human beings as equals. This is a fine example of the spirited brushwork of Saigo Takamori, one of the central figures of the Meiji Restoration and one of Japan's most popular (tragic) heroes. Saigo was a huge, heavyset man, so the brushstrokes are unsurprisingly "meaty," thick, and solid. This calligraphy is the most substantial example presented in this book.

敬天愛人

TWO-LINE CALLIGRAPHY

Make light of worldly affairs.
Sport in splendid solitude
Far beyond the world of dust;
Forget about this and that,
Awaken from within,
And view all things with equanimity.

Nanshu brushed [this]

Saigo's calligraphy is big, bold, forceful, and determined, just like the man himself. He was deadly serious with his brushwork—it is said that he was covered with sweat after a session of calligraphy. Although he was a highly public figure most of his life, Saigo was a keen practitioner of Zen meditation and spent as much time as he could in quiet retreat.

玩世留連荳蔲梢頭

長樣自覺梅情霄齋

STAFF

Speak and you get the Nanten staff; do not speak and you get
 the Nanten
BO! (Staff)

[signed] Seventy-plus-four-year-old fellow Nantenbo Toju

The staff in the middle serves as both a painting of Nantenbo's staff and the last character of the inscription. The calligraphy on both sides of the painting form little staffs. Nantenbo is telling us, "The essence of Zen transcends speaking and nonspeaking; clever words or mere silence will not cut it. Unless you really demonstrate Zen to me, you will feel a good whack of my staff."

Nantenbo, a close colleague of Tesshu, carried his trademark staff wherever he went and applied it liberally to "wake up" his students.

ONE-LINE CALLIGRAPHY

Everyday mind is the Way!

Brushed for Mr. Ueno
By seventy-six-year-old fellow Nantenbo Toju

The phrase "Everyday mind is the Way" (*byodo shin kore do*) appears in case 19 of the *Mumonkan*. Joshu asked his master, Nansen, "What is the Way?" Nansen told him, "Everyday mind is the Way." The case goes on as Joshu asks, "Shall I try to get on it?" Nansen replies, "If you try to find it, you will become separated from it." Joshu: "Then how can I know where it is?" Nansen: "The Way is not about knowing or not knowing. Knowing is delusion; not knowing is confusion. When you find the true Way, you will see that it is as vast and boundless as the cosmos. The Way can never be described as this or that." Upon hearing those words, Joshu woke up.

This phrase is often used in connection with the martial arts to represent the ideal state of mind when facing external and internal enemies.

PART THREE

MODERN

CHINESE-STYLE POEM

I am greeted by bundles of tea and kegs of wine.
I stroll through a bamboo forest
And then walk along a road beneath broken clouds.
At sunset I pass a temple casting long shadows.
I stop along a river to watch swans swim by.
Then I board my boat and catch golden-scaled fish.
What a pleasant day passed in my village—
I leisurely drift home in my boat.

Brushed by Seiko at the Ink Spewing Cloud of Smoke Pavilion

The brushwork in this wildly creative calligraphy, with the individual characters composed in all manner of shapes and sizes, roams up and down the paper. It is a classic Chinese-style poem of seven words in eight lines. While the characters are idiosyncratic, each one can be recognized by a knowledgeable connoisseur. However, I included this piece to illustrate how it is possible to appreciate calligraphy without knowing what any of the characters mean. It is the total effect of the brushwork, not the individual elements, that makes an impact. One aspect that stands out is the "free spirit" of the artist displayed in the brushwork. Seiko was known for her buoyant, nonconformist lifestyle—she didn't adhere to any rules. Calligraphically, the brushwork here seems to defy all rules of composition, but it works. Reproducing it in standard printed characters ruins its effect. It is best appreciated as a whole rather than in parts.

茶標酒望遠相迎筍竹攜人似。輕新
堤路暗夕陽翻影寺櫻昭僑江白蹤鄰帆從之上繩金鱗
溪剌鳴是窮江卿志在樂扁舟栽欲等潯生

陽春事年再到湖上書扵琴軒獨奇棖

ONE-LINE CALLIGRAPHY

Focused effort, maximum efficiency, mutual well-being and benefit.

Seiryoku zenyo jita kyoei

Shinkosai

Kano Jigoro was the founder of Kodokan judo. *Seiryoku zenyo jita kyoei* (精力善用自他共栄) was his guiding principle. In judo and all aspects of life, one should focus on one's strengths and apply those principles to the broadest possible advantage, both for oneself and society at large. Shinkosai is the pen name Kano used in his sixties. The brushwork is clear, bright, and perfectly centered and balanced.

精力善用身他共榮

嘉平高

ONE-LINE CALLIGRAPHY

Effort Ensures Results

Kiissai

Another interpretation of "Effort Ensures Results" (力必達) could be "Strive and you will arrive." The first character literally means "strength." In judo, strength is not only physical but spiritual. In fact, without moral and spiritual strength, even the most powerful force will eventually dissipate. Kano, the founder of Kodokan judo, equated strength with ceaseless effort. If you make great effort, it will surely lead to great results, regardless of the endeavor or the challenges. The brushwork is clear, lucid, and perfectly centered and balanced.

力必達

帰一 高

HORIZONTAL CALLIGRAPHY

Search for the Way
(Tando)
Kiichisai

Tando is 探道. Judo is not the way to search for victory; it is the way to seek fulfillment. The brushstrokes are supple and bright. Since Kano brushed the majority of his calligraphy while he was visiting places all over the world, the sheets were left unsealed. However, this piece was brushed on high-quality silk with three of Kano's seals carefully impressed on the surface, so it was likely done by special request.

搾道

帰一翁

TWO-LINE CALLIGRAPHY

First hardship, later ease;
First ease, later hardship.

Shinkosai

This proverb defines human life. First there are painful experiences, and later there are pleasant experiences; or first there are pleasant experiences, and later there are painful experiences. In brief, our lives are a mixture of positive and negative experiences. Do not be overly elated when things are pleasant; do not be overly sorrowful when things don't go well.

A more social interpretation is "Only after others find pleasure is it acceptable to seek your own." For leaders, it is "First work to assure the people of their happiness, and then be concerned about your own."

先憂事者後樂事

先樂事者後憂事

延平高書

CALLIGRAPHY

The ancients, through piercing discipline, became brilliant
And without fail accomplished great things!
Yamada Jirokichi brushed [this]

As a young monk, the ninth-century Chinese master Jimyo used a drill to pierce his thigh whenever he felt drowsy during Zen meditation. When asked why he did such a painful thing, Jimyo replied, "The ancients, through piercing discipline, became brilliant and without fail accomplished great things. To achieve nothing in one's lifetime and to die without any accomplishments is a terrible waste. That is why I pierce my thigh!"

Yamada Jirokichi, fifteenth and last headmaster of the Jikishin Kage Ryu, was known to have such a similar approach. He used to pound his head against a post to make it able to withstand the strongest blows of the *shinai*—he let his opponents freely bash him on his kendo helmet. As we can see here, Yamada was an outstanding calligrapher of kaisho. The brushwork is best described as serious and intense.

古人刻苦光明必盛大也

山田次朗吉書

TWO-CHARACTER CALLIGRAPHY

Muge
Hakudo

Muge (無礙) means "no obstacle," "unobstructed," "unimpeded," and "unhindered." It is a key term in both Zen Buddhism and the martial arts, representing a state of being where nothing blocks a person in mind or body. A physical barrier can only be overcome by not getting trapped by it mentally. Whatever occurs on the battlefield of life, or in the realm of the mind, deal with it in a state of muge. Muge is different from *mushin*, "no-mind." Mushin is more of a mental attitude, whereas muge is a more active approach. This large calligraphy was meant to be displayed in a dojo.

霊樹

MOUNT FUJI

The eight lotus petals have freshly opened.

Year of the Water Ram, autumn [1943]
Tempu painted and inscribed [this]

When Mount Fuji is crowned with the first snow of winter, the peak is said to resemble eight petals of a lotus. The popular philosopher Nakamura Tempu was the founder of *shinshin-toitsu-do*, an integrated system of martial arts, yoga, and the power of positive thinking. He was also a committed artist, producing a huge corpus of brushwork, calligraphy, and painting. As we can see here, Tempu was quite a talented artist, perhaps the best of any budo master of the day. His Fuji differs from the other Fuji paintings in this book: it is certainly not a zenga composed of a few strokes, but a conventional work of art produced along professional standards.

It is almost decorative, but the work emerges from a solid core. It is, in a word, positive.

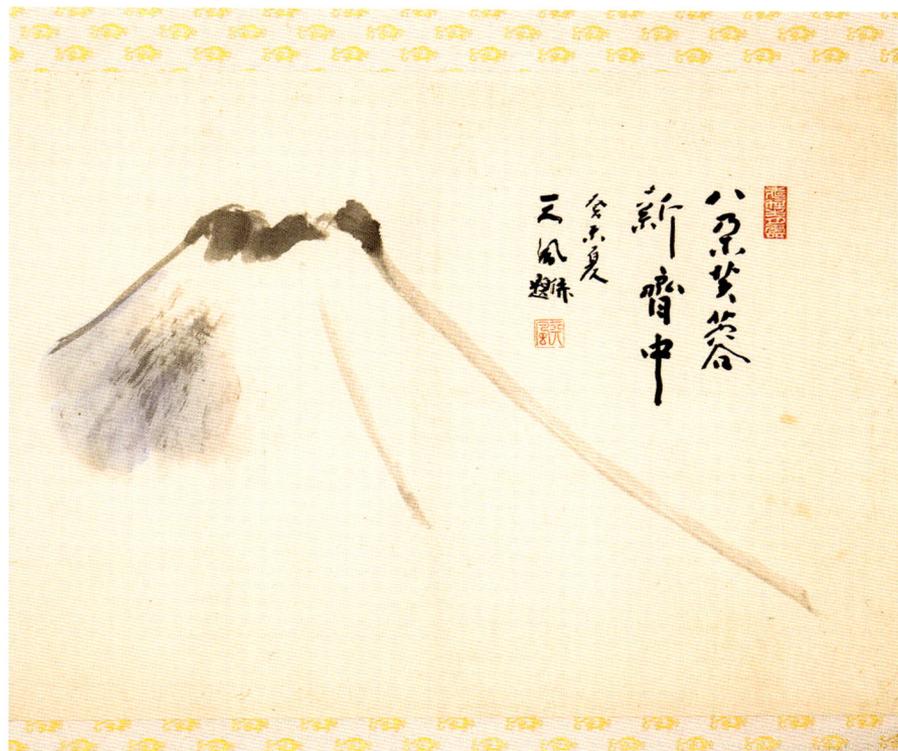

TWO-CHARACTER CALLIGRAPHY

Search for the Way
Showa Year of the Monkey-Dog [1934]
Koko brushed [this]

The two characters (求道) can be pronounced in two ways: *gudo* ("search for the Way") and *kyudo* ("the Way of the bow"). Awa Kenzo's life combined both meanings: "Practicing kyudo while seeking the Way." The brushwork is calm, settled, and supple. It is clearly the calligraphy of a budo master. While Awa—the kyudo master made famous by Eugen Herrigel's classic *Zen in the Art of Archery*—was a throwback to the old-time budo masters in demeanor and teaching style, he was a revolutionary in thought. After a long period of introspection Awa came to the realization that "drawing the bow with a Zen mind" was the true purpose of kyudo: "One shot, one life. Shoot every arrow as if it was your last. With each release of the bow see into your Buddha-nature." For Awa, kyudo was not a sport, it was a way of life, a vehicle of transformation.

Unlike the other budo masters of the twentieth century, examples of Awa's brushwork are exceedingly rare. In forty years, I have actually seen only a handful, even though I lived in Sendai, where Awa spent most of his life. This one was brushed when Awa was fifty-four-years old.

求道

昭和甲戌初冬
宏澗書

ONE-LINE CALLIGRAPHY

Love learning,
Think deeply,
Know the heart,
Get the meaning.
Brushed by Koun Gakujin

This is a well-known Confucian sentiment brushed in classic clerical script by one of the greatest Zen archers of modern times, Suhara Koun. Koun Roshi was an inheritor of Awa Sensei's Bow and Zen tradition and became a missionary to introduce his master's kyudo to the West. As with Awa, calligraphy by Suhara is quite rare.

好學深思心知其意

甲寅學人書

Great Spirit of Aiki
AI KI O KAMI
Tsunemori

Aiki Okami is the all-inclusive spirit of aikido, the supreme symbol of aikido ideals. The brushwork is calm and luminous. There is also a sense of deep respect, even affection, for Aiki Okami. In his seventies, Ueshiba used the name Tsunemori, "Always Abundant."

合氣大神

TWO-CHARACTER CALLIGAPHY

BUSHIN

Morihei respectfully brushed [this]

On the lowest level, *bushin* (武神) are "war gods." Every culture has its own set of gods of war. Early on, some cultures viewed bushin more in terms of "protector gods," guardians of the peace rather than aggressors or avengers. Philosophers such as Morihei even saw "martial" and "divine" as being two sides of a coin and not separate things. The tail brushstroke of *bu* soars upward to heaven while the central stroke of *shin* reaches down to earth. He considered Japan (and by extension, the entire world) to be built on the two pillars of bravery and holiness. On an individual level, bushin is the spirit that guides one along the path of courage and commitment for the protection and welfare of the nation. Bu can also be taken as "good governing."

武神

MYOGO

Ame-no-murakumo-kuki-samuhara-ryu-o-ookami
Morihei

Morihei had the experience of being possessed by this Dragon King; it became his guardian deity in particular and the protector of aikido in general. He brushed "Holy Name" talismans like this hundreds of times for presentation to his disciples. In this case, with the addition of *ookami*, it signifies that it is the "Great God Protector" of aikido. The brushwork manifest here is visual *kundalini*.

136

天の村雲九頭さむはら龍王大神

ONE-WORD BARRIER

Love

(Ai)

Morihei respectfully brushed [this]

Not surprisingly, *aikido* (合気道), "the Way of Harmony," can also be written as *aikido* (愛気道), "the Way of Love." Literally, *aiki* means "integration of energy between two forces," while *aiki* is "integration of individual loving spirits." Morihei also wrote, "Aikido is the actualization of love."

Morihei considered Ai to be divine—here he added "respectfully brushed," the phrase used when addressing a divinity, to his signature. The character indeed looks like an image worthy of veneration. The line along the top is composed of drops of ink—the drops are considered to be just as much a part of the artwork as the regular lines.

138

愛

MYOGO

Katsu hayabi
Aiki Morihei

I translate *katsu hayabi* (勝速日) as "Victory right now, right here," taking *haya* to be "instantaneous" and *bi* to be "on this day, in this place." There are many other interpretations, such as "Attain victory with techniques that cannot be seen [i.e., beyond time and space]." It is up to the individual to come up with an interpretation based on their own experiences.

Morihei's brushwork is the most idiosyncratic of any master in this book, and this piece takes the cake for its wild composition. It appears that he brushed it in one breath and actually raced off the paper, so part of the last character got cut off. In addition, he stamped three of his seals randomly in places a calligrapher would never think of putting them. There is nothing like it.

暁連日

DARUMA

Oni

This giant Daruma is brushed by Morihei's guru, Onisaburo Deguchi. Signed Oni (王仁), it is rather different from the other Daruma portraits featured in this book, which were created by Zen Buddhist practitioners. Onisaburo never spent a minute in Buddhist meditation; rather, he was communing with various deities. Nonetheless, he captured Daruma's Zen energy quite well. Daruma's expression is fierce but not frightening. Onisaburo would likely tell you that he actually met Daruma in person during one of his celestial excursions.

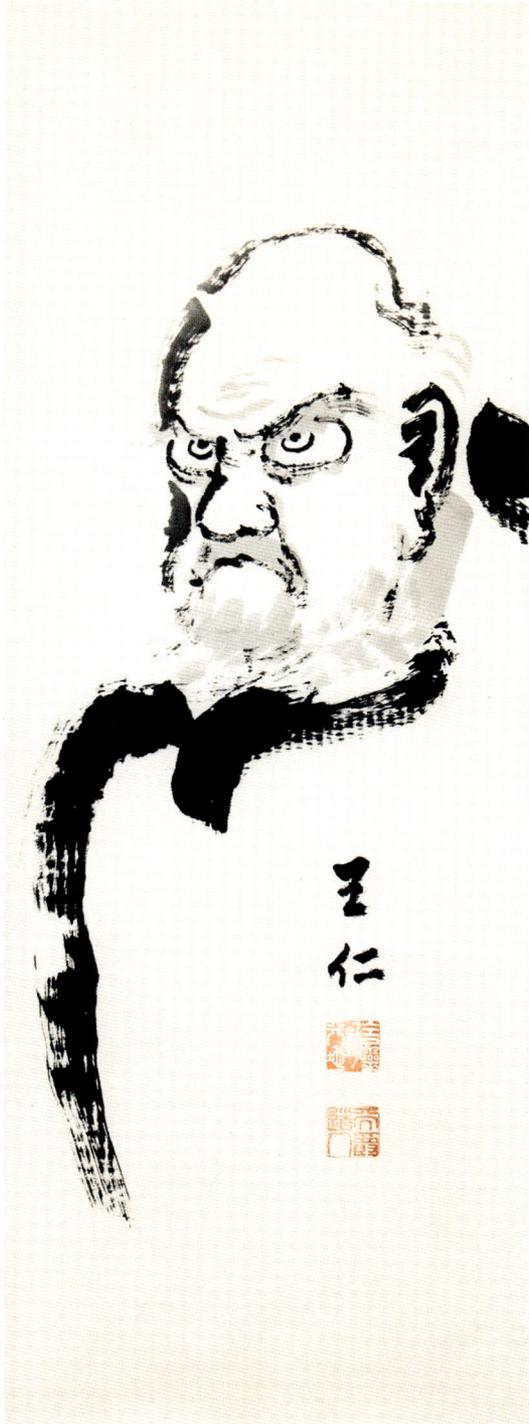

王仁

ONE-WORD BARRIER

Light
(Hikari)
Aikido teacher, Korin (kao)

The last character Morihei brushed before his passing was *hikari* (光), "light"; it was his final statement. Morihei's disciple Shirata Rinjiro often described aikido as *Hikari no michi*, or "Way of Light." (Korin, "Light in the Forest," was Shirata's sobriquet.)

合気道師
光林

ONE-WORD BARRIER

Yu

North Peak Great Ajari
Hoju-in Yusai

The character *yu* (勇) means "bravery," "courage," and "determination." Sakai Yusai was the amazing Marathon Monk of Mount Hiei, who completed two seven-year, thousand-day *kaihogyo*. These daily pilgrimages run for periods of one hundred days and range from forty kilometers a day in the first years to sixty kilometers in the middle years and then eighty-four kilometers in the last year. Not surprisingly the character seems to be running across the paper.

勇

北碛大圩㴍

齊年珺光 戠

ZEN SNOWMAN

Form is Emptiness, Emptiness is Form!

Deiryu

Paintings of a *yukidaruma* (snow Daruma) are a common theme in zenga, usually accompanied by an inscription of the most famous line of the Heart Sutra: "Shiki soku ze ku, ku soku [ze] shiki." The snowman materializes—in the depth of winter, it is as solid as can be—but when the weather begins to warm up, the snowman gradually melts away. The reality of "form is emptiness, emptiness is form" can actually be seen in the appearance and disappearance of the snowman in a single, short season. This Zen snowman has a rather alarmed expression—he realizes that he is beginning to melt.

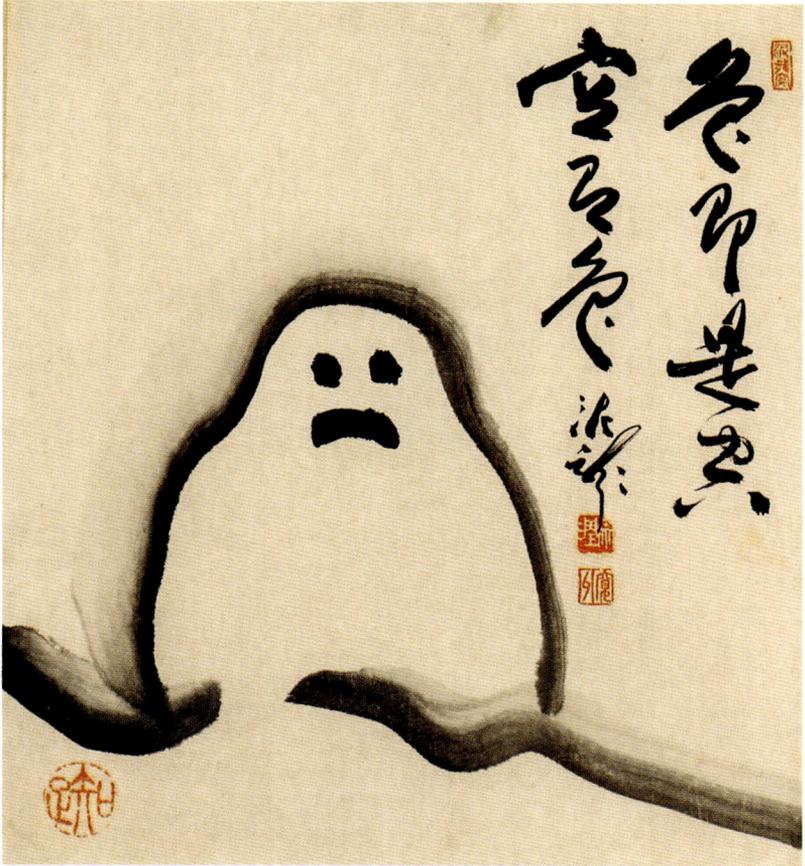

MYOGO

Hannya Haramita Shingyo
(Prajna Paramita Heart Sutra)
Tanchu Koji respectfully brushed [this]

In this book, there is the entire text of the Heart Sutra brushed by Tesshu, but here in this calligraphy by Terayama Tanchu, we only have the name—a powerful mantra. (The characters 波 and 羅 are run together.) The Heart Sutra is a mantra. Despite centuries of trying, in countless commentaries, no one has come close to explaining it; the whole point is that it can't be explained. *Prajna paramita* is the "perfection of wisdom"; it doesn't need to be explained further.

The brushwork displayed here is what we describe today as avant-garde. It has a more playful, artistic bent than the other examples in this book. Also, Prajna paramita is the name of the ultimate female bodhisattva—Mother of All Buddhas. Thus, the calligraphy has a softer, willowy touch.

PART FOUR

..

TESSHU

TALISMANIC MAGIC DRAGON

Dragon—
Offers to the sun
The water of the four seas!
Tesshu Koho brushed [this]

A calligraphic magic dragon is brushed to serve as a talisman to pro-
tect a family from the seven disasters: fire, flood, drought, earthquakes,
pestilence, war, and irate fathers. To be effective, the dragon needs to be
brushed in one dynamic stroke, in one long breath, to animate it. The
inscription is an incantation to the water dragon, thought to be able to
control rainfall by surrounding the sun with moisture and to control the
ebb and flow of the four seas by swimming in the oceans. Such dragons are
believed to work best when brushed by those of high spiritual attainment.
Dynamic calligraphic dragon talismans brought to life by Yamaoka Tesshu
are in the highest demand.

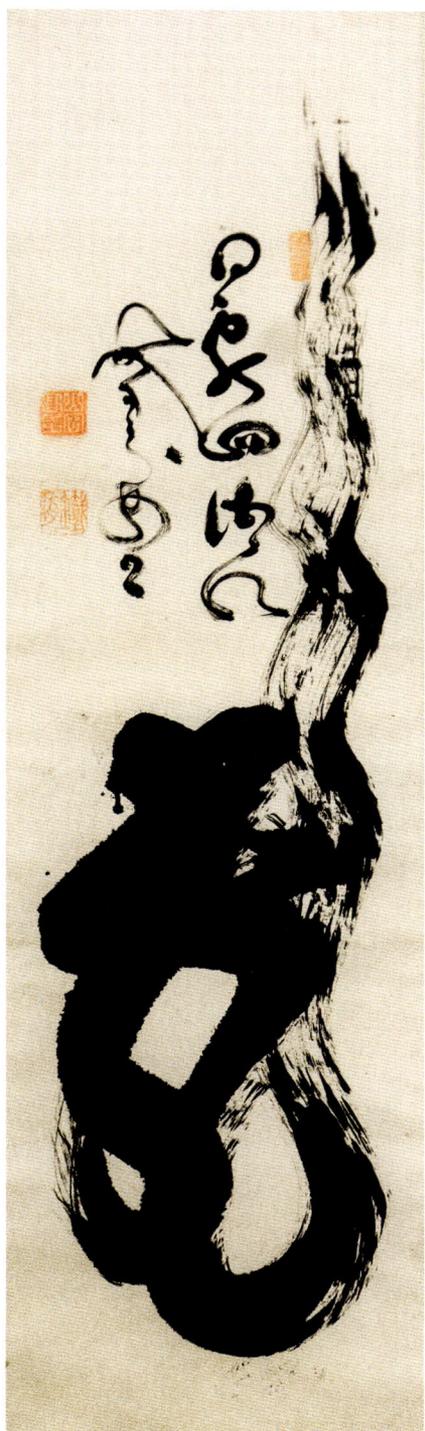

DRAGON AND TIGER CALLIGRAPHY

Dragon
Tiger
Tesshu Koho brushed [this]

The dragon and the tiger represent the two great forces of nature: yin and yang, heaven and earth, water and wind, finesse and brute strength, evanescence (clouds) and deep roots (bamboo). The dragon and the tiger are in opposition and can be deadly rivals if there is not perfect harmony between them. Indeed, life is a delicate balance between the dragons and tigers that confront us every day. Pictorially, the dragon is portrayed in a whirl of clouds, while the tiger is shown in a bamboo grove. The pair is often depicted as calligraphy, as we have here. The brushstrokes (in cursive script) of the two characters are linked, and the impression is of one entity rather than two separate beings. The flying white of the brushstrokes, giving the calligraphy a three-dimensional quality, is created by the brush running across the tatami mat underneath.

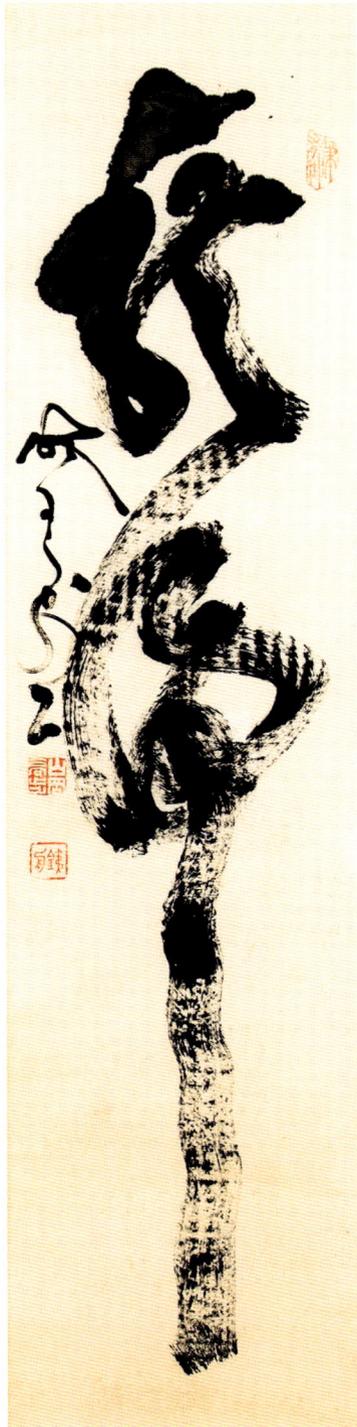

MOUNT FUJI

Good when clear, good even when cloudy—Fuji mountain's
original form never changes.

Koho

Life is full of changes, alternating between sunny and dark days, but our
innate Buddha-nature, pure and majestic, remains undisturbed. Tesshu's
Fuji, the simplest painting possible, is formed by three lush brushstrokes.
It is a masterpiece of minimalist Zen art, and the rhythmic flow of the
calligraphic inscription is outstanding. This is Tesshu's best-known poem.
In Japanese, it reads:

harete yoshi
kumorite mo yoshi
fuji no yama
moto no sugata wa
kawarazari keri

It is widely reproduced by calligraphers and appears in many publications
(including high school textbooks).

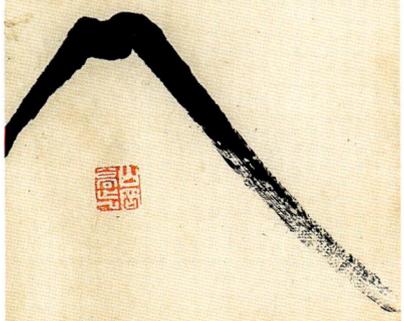

CALLIGRAPHIC MAGIC DRAGON
AND PICTORIAL MOUNT FUJI

Tesshu Koho brushed [this]

This zenga appears massive, but it is in fact composed of four strokes to form Mount Fuji and one stroke to create the ascending dragon. The dragon looks as if it is ready to fly off the paper. Tesshu's dynamic signature is as tall as Fuji; it is man, mountain, and dragon as an integrated whole.

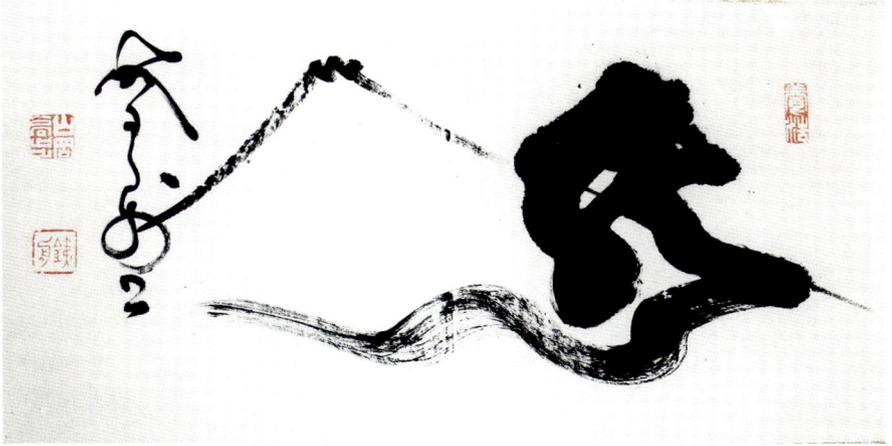

MOUNT FUJI AND SNAIL

One in mind and body, what cannot be accomplished?
If a snail wants to climb Mount Fuji
Surely it will make it!

Tesshu Koji brushed [this]

Human beings can accomplish anything if they set body and mind to the task. Even a snail can make it to the top of Mount Fuji if it is determined to do so. This theme was one of Tesshu's favorites, and he brushed it often. The spirited calligraphy flows up and down the paper with a powerful rhythm.

MOUNT FUJI AND COUPLE

You will live to a hundred, I will live to ninety-nine.
[As together we gaze] on the peak of Mount Fuji and the
 Pines of Miho.

Tesshu Koho brushed [this]

This charming theme was a favorite of Tesshu. It depicts two people who
have grown old together—as close and considerate of each other as can
be—in a state of harmony, gazing on the beauty of nature. This is as close
as we can get to paradise on this earth.

Miho no Matsubara, the Pine Grove of Miho in Shizuoka, is one
of Japan's Three Great Views. Mount Fuji towers over a seashore lined
with beautiful green pines and white sand. The enchanting scene is fre-
quently reproduced in Japanese art. While studying with Master Seijo of
Ryutaku-ji in Shizuoka, Tesshu would make the long, seventy-five-mile
walk from Tokyo on his day off from the Imperial Palace, his constant
companion being Mount Fuji. He was quite familiar with Fuji's moods
and shifting tints.

ふるさとわかれやすらひて
つきをかたびらをみほの松

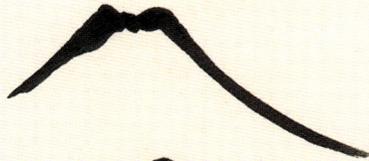

KENJUTSU

The innermost secrets of swordsmanship—
like the wind in the willows.

Tesshu Koho brushed [this]

This *men* and *shinai* theme was brushed for kendo practitioners. The shinai is depicted as being much longer than it actually is, the idea being that one's ki does not stop at the end of the physical sword—it extends through the opponent's body and mind and does not settle on one point such as a *men* strike or *kote* cut. The inscription is a haiku:

> kenjutsu no
> gokui ha kaze no
> yanagi kana

Gokui (極意) can also be translated as "hidden principle," "mysteries," and "essence." The term *kaze no yanagi* (風の柳), or "wind in the willows," is a metaphor for being infinitely flexible in mind and body, coupled with the most graceful movements, against powerful forces. In sumo, there is a similar haiku: "When the opponent shoves with all his might, deal with it like a willow branch."

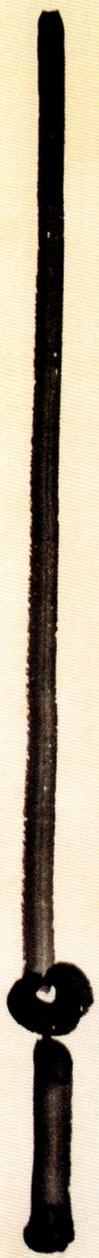

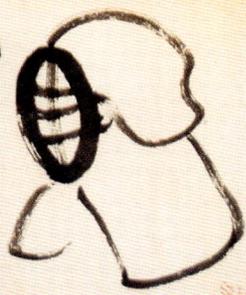

SWORD

Asking for the inner secret of kenjutsu
Is like asking me to brush on an ink painting
The sound of wind in the pines.

Tesshu Koho brushed [this]

It is clear that the person seeking the secret of swordsmanship was sitting next to him. "If you want to know the secret of swordsmanship, I will paint it for you." Tesshu brushed the sword, but the secret was not spelled out—that is like trying to draw "the sound of wind in the pines." That expression comes from a poem by Ikkyu:

The mind—
What can we say?
It is like the sound of
The wind in the pines
Brushed on an ink painting.

The secret of swordsmanship is tangible but not concrete. This large scroll is a big visual swordsmanship koan.

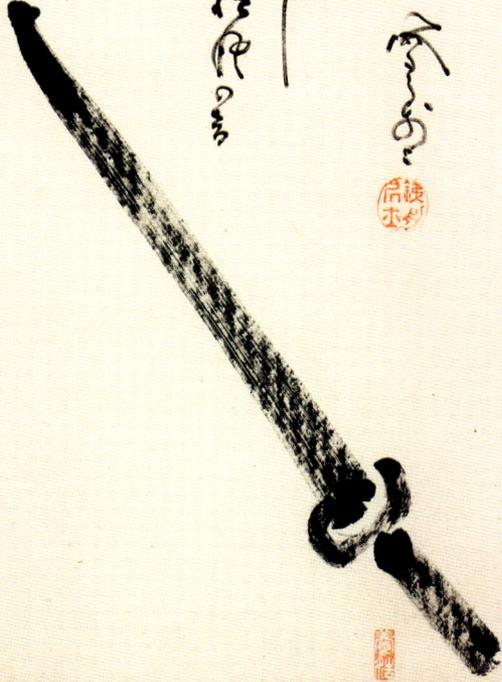

SWORD AND SKULL

When faced with a great challenge
how do you handle it?
Tesshu Koho brushed [this]

The inscription in Japanese is *sho yomo soku somosan*. *Shomo* is a Buddhist term meaning "directly confronted by," "faced with the harsh reality," and "this is how it is." *Soku* means "immediately." *Somosan* is "What about it?" or "What will you do?"

The sword and the skull paired together represent a life-or-death encounter. The inscription demands, "How will you deal with the great matter of human existence both in an instant and in the long run?"

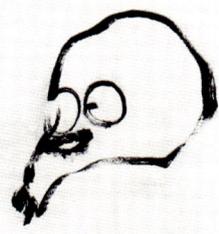

SKULL

Don't be scared
Of this weather beaten,
Abandoned old skull;
It is a matter of congratulation
Better than any other!

Tesshu Koho brushed [this]

On New Year's Day, the famous Zen master Ikkyu walked around the town brandishing a human skull and shouting, "Beware, beware!" When asked why he would do such a thing on a day of celebration, Ikkyu recited the poem shown here. (Tesshu's reading on this painting defers slightly from the standard version.) The meaning: "If there is death, there must have been life. That is a matter of congratulation; but since life will end as death, don't waste your time on frivolous pursuits." In short, "Live completely, die completely," which was Tesshu's motto.

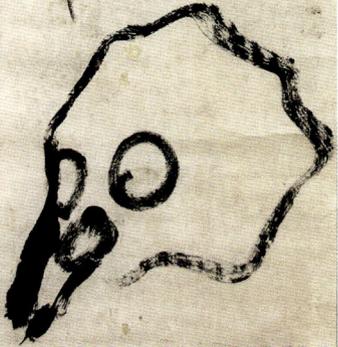

DEMON ROD

People who fear this demon rod will be on the way to paradise!

Tesshu Koho brushed [this]

This is a zenga of the thick iron rod employed by demons to beat evildoers as they fall into hell. Like so many zenga, this popular theme originated with Hakuin.

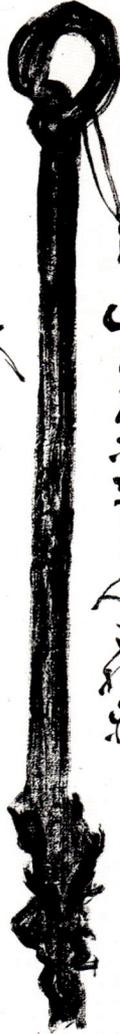

FUDO MYO-O (DETAIL)

Fourth Imperial Rank Yamaoka Tetsutaro respectfully brushed [this]

Fudo Myo-o is one of the most popular figures in the huge Buddhist pantheon. He is typically depicted as we see him here, sitting within a flaming nimbus; he holds a lasso in his left hand to subdue evildoers and a sword in his right to cut off ignorance. He is attended by two boy servants, Kongara (left) and Seitaku (right). Fudo Myo-o has many devotees, especially among martial artists and mountain ascetics (*yamabushi*).

This is a close-up portrait of Narita-san Fudo Myo-o, worshipped at the Narita-san Temple in Chiba (成田山 is written under Fudo's seat). Such images were distributed all over Japan to be enshrined in family altars. As described in *The Sword of No-Sword* (page 79), Tesshu brushed this talisman a few months before his death. As was his wont, during a session he brushed dozens, or even hundreds, of sheets on the same theme. Tesshu seemed to go into automatic Zen pilot when he worked like this. It was one sheet after another, moving meditation, without a technical or spiritual break.

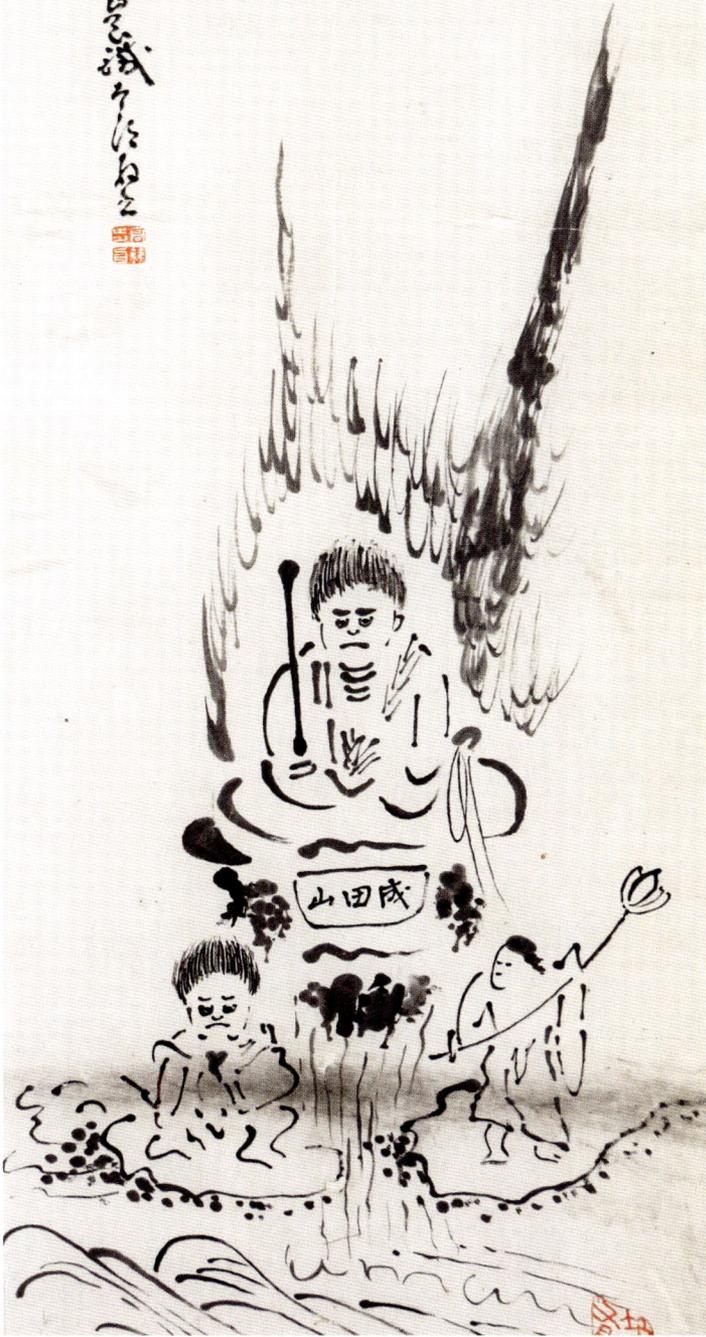

SCARECROW

Even if it falls it does not abandon its bow and arrow
The scarecrow . . .

Tesshu Koho brushed [this]

Day and night the scarecrow is always on duty—performing its task with-
out thinking about it—and even if it falls down, it still holds on to its bow
and arrow. This is the ideal of the samurai warrior (and Zen practitioner):
forever diligent and never giving up. Tesshu brushed this theme often, and
this zenga is an especially fine example.

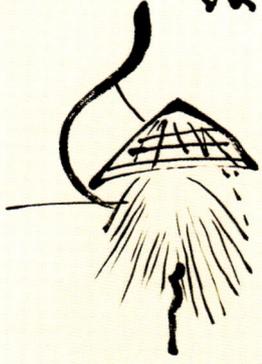

DARUMA

Vast emptiness
Nothing holy!
Tesshu Koho brushed [this]

Bodhidharma's interview with the Chinese emperor Wu went like this:
 Wu: I have built numerous temples, commissioned many sutras, and
 supported hundreds of monks and nuns. How great is my merit?
 Bodhidharma: No merit!
 Wu: What is the first principle of Buddhism?
 Bodhidharma: Vast emptiness, nothing holy!
 Wu: Who are you?
 Bodhidharma: Don't know!
 This style of side-view Daruma is one of Tesshu's trademark zengas.
The First Patriarch is telling us, "Zen transcends all formulas and notions
of sacred and profane." A painting of Daruma can be a spiritual self-
portrait. Frequently, the Daruma physically resembles the artist; this one
does indeed look like Tesshu and projects a "living presence."

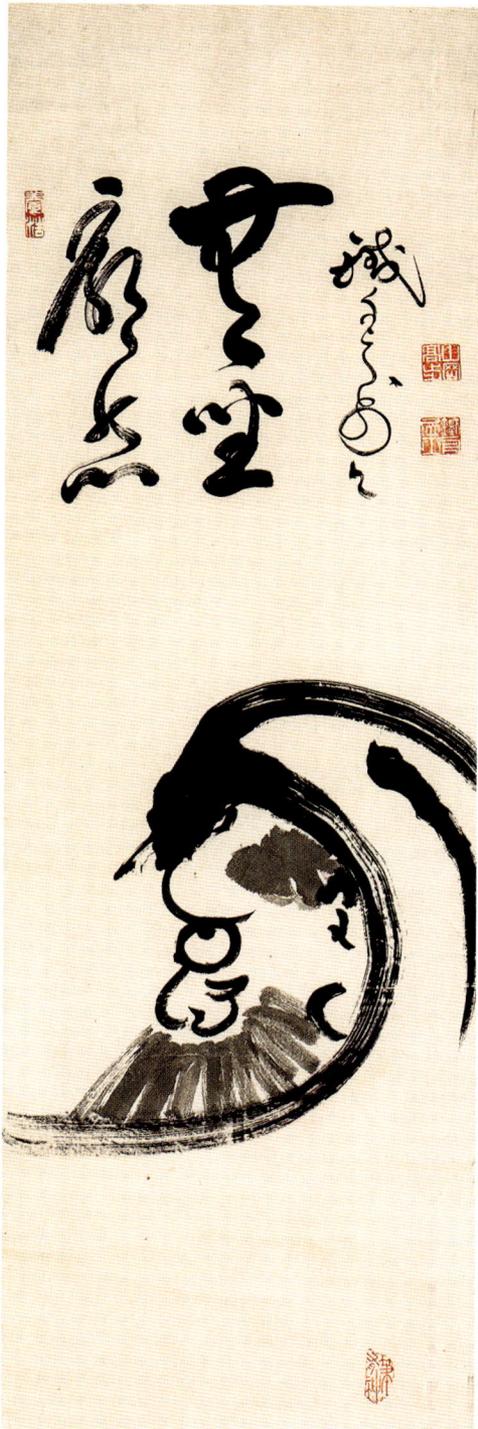

DARUMA

[Zen] points directly to the human heart,
See into your nature become Buddha!

Kaishu

[Painting by] Tesshu Koho

This huge Daruma is a joint work with Tesshu doing the painting and
Kaishu the inscription. The inscription by Kaishu conveys the essence of
Zen. Zen directs you to the core of your being; that is where you must
find your own true self and wake up. The portrayal of Daruma by Tesshu
is especially dynamic, even fierce—a kind of no-holds-barred, take-no-
prisoners approach.

WALL-GAZING DARUMA

[Zen] points directly to the human heart,
See into your nature become Buddha

Deishu Koji
Yamaoka Tesshu Painting

Here is a collaborative effort of Deishu and Tesshu to create a Wall-Gazing Daruma, representing Daruma turning his back to the world and sitting like a rock in meditation in front of a wall. His body is formed out of two characters: 乃 (direct) and 心 (heart). The three elements—two characters and one body—form Wall-Gazing Daruma. (This is a woodblock print of an original joint composition.)

直指人心
見性成佛

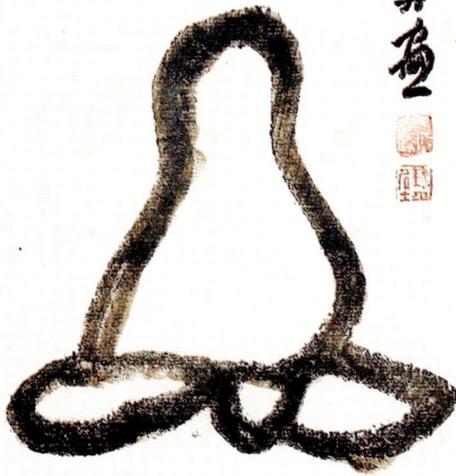

HYOJU (MAGIC JEWEL)

Fourth Imperial Rank Yamaoka Tetsutaro brushed [this]

This is a *hyoju*, a flaming magic jewel that grants any wish. (In Hindu and Buddhist traditions, the jewel is known as *mani* or *cintamani*.) A painting of a magic jewel is hung during the New Year season to serve as a good luck charm that will make all one's dreams come true. The best way to be blessed is to live a good life, behave well, and be content with what you have. In Zen, the magic jewel is believed to purify the mind, liberate one from negative passions, and lead to enlightenment; once you have that, everything seems like a gift.

The magic power of this huge zenga is overwhelming. It blows you away when you look at it. It is almost scary in its intensity. It appears to be three-dimensional, exploding through space.

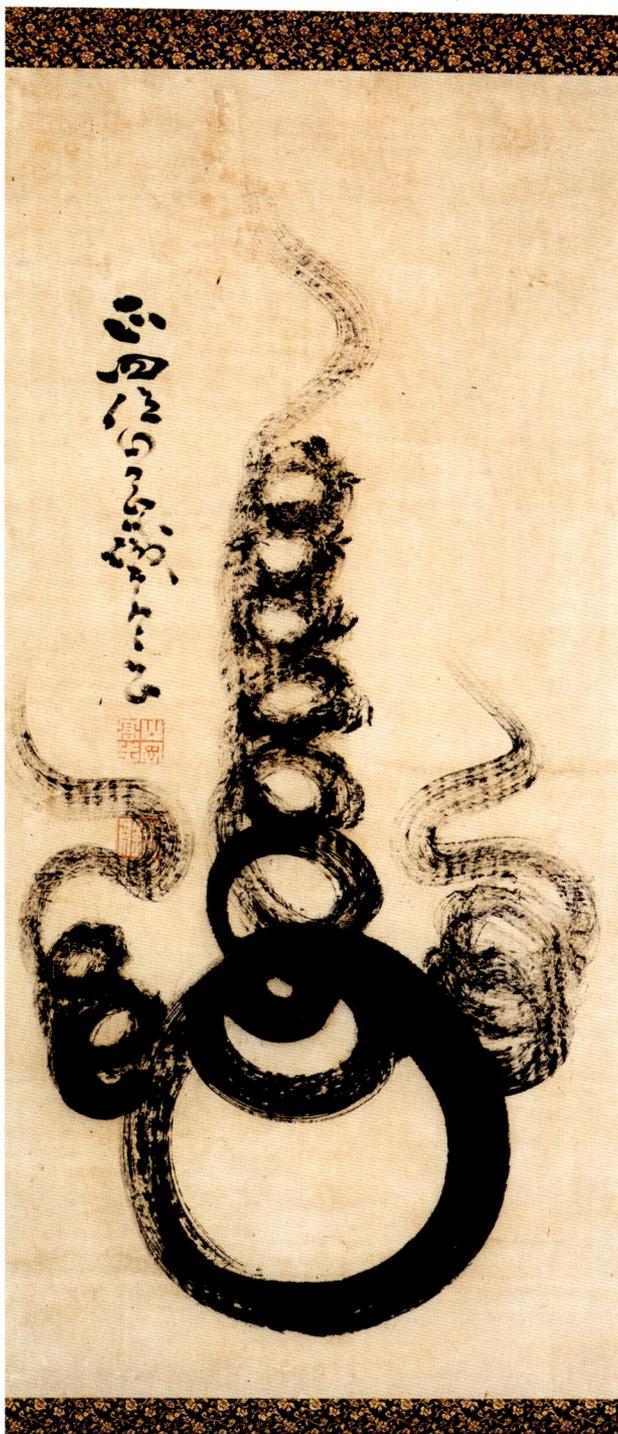

MAGIC JEWEL KETTLE

A hundred affairs are precious jewels.
Tesshu Koho brushed [this]

In this zenga, the magic jewel is depicted as a kettle hanging from a *jizai* over a hearth. "A hundred affairs" means all the acts and affairs of daily life, so the inscription can be interpreted as "Every single thing is precious." That is, in everyday life there should be no distinction between important and insignificant deeds. Any act or event can be a vehicle for Zen realization.

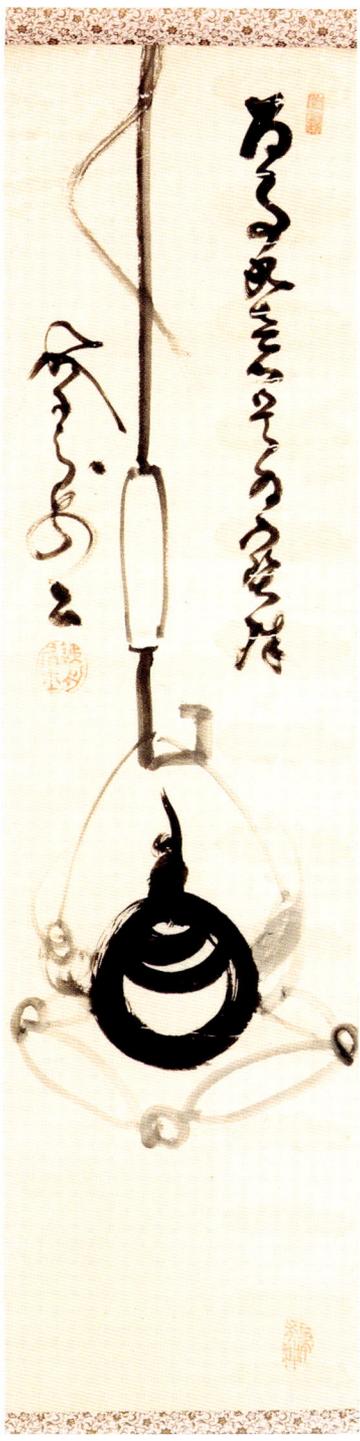

HORSE

In ten thousand human affairs remember Old Man Sai's
Horse

Tesshu Koho brushed [this]

This is the story of Old Man Sai, who lived near the border of ancient
China. One day his favorite horse ran away. His neighbors said, "Bad
luck." Sai just smiled. A few days later, his horse returned, together with
a magnificent wild stallion. "Good luck," his neighbors told him. Sai just
smiled. His son tried to ride the new horse but was badly thrown, breaking
his leg. "Bad luck," his neighbors commiserated. Sai just smiled. War broke
out in the district, and all the young men in the village were drafted and
sent to the front except for Sai's son, who was still laid up. "Good luck,"
everyone told Sai. He just smiled. (The painting of the horse also serves
as the character for the horse of the inscription.)

In other words, "There is a silver lining to every cloud." Life is full of
changes, and it is best to meet every situation with equanimity.

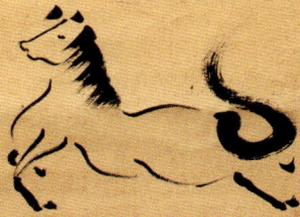

ONE-LINE CALLIGRAPHY

[Behave as a] Spirited young stallion galloping a thousand miles!

Tesshu Koji brushed [this]

A superb one-liner by Tesshu, beautifully mounted and in perfect condition. The brushwork itself seems to be galloping down the paper. This was likely brushed to inspire his young disciples.

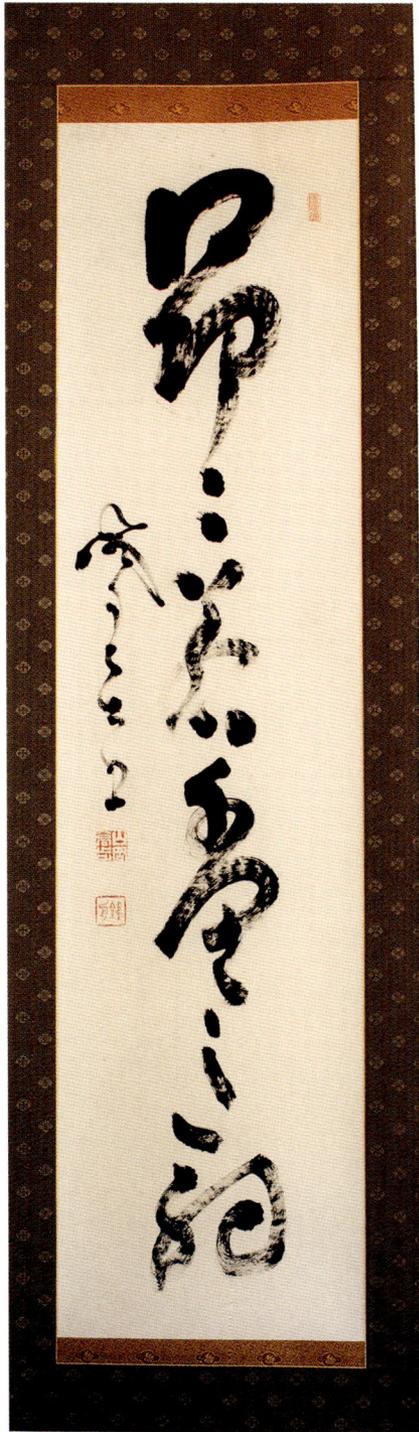

MONEY

When you hear that there is money, you become eager to get it;
When you do get it, you want an armory
to protect it!

Tesshu Koho

This is a painting of a coin minted during the Bunkyu reign (1861–1863). (The reign year is impressed around a center square.) Tesshu was famously indifferent to money. He gave all of his away, even the money the emperor gave him to get a new set of clothes for his duties in the palace. Tesshu continued to wear the same shabby outfit.

あられもなき ...

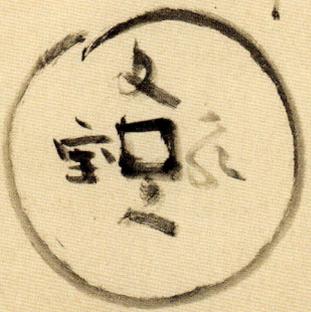

BAMBOO

A fresh breeze caresses a bamboo shoot.

Tesshu Koho
[painting by] Kokoku

This is a beautiful father-daughter collaboration. Kokoku was the sobriquet of Matsuko, Tesshu's eldest daughter. She was—among other things—an accomplished artist, and such joint works with Matsuko doing the painting and Tesshu adding the inscription are often seen. This is one of their best collective efforts. There is a real connection between the painting and the inscription that is not normally found in collaborative works. Perhaps that connection is due to the flesh-and-blood relationship of the two artists. From Tesshu's signature, it appears that the painting was brushed around 1885.

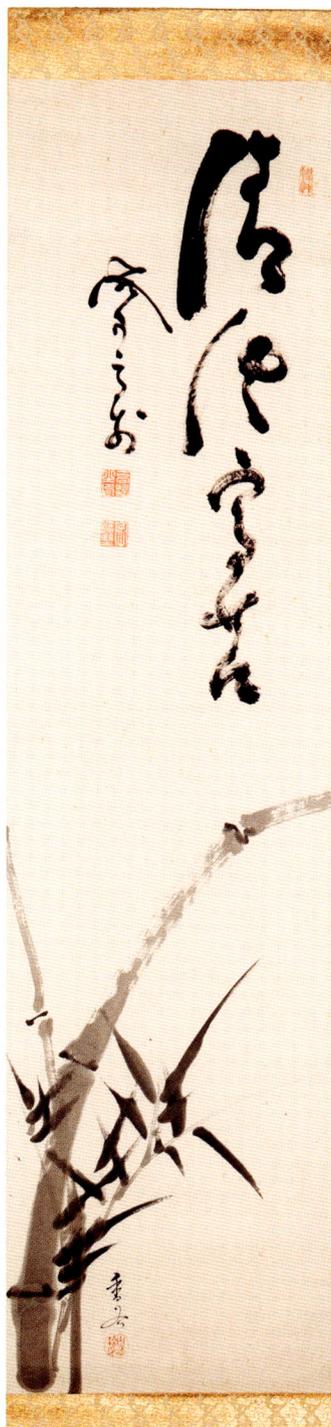

ONE-WORD BARRIER

Mu

Tesshu Koho brushed [this]

Mu is the central koan of Zen, said to be the most difficult puzzle to solve. One-word barriers such as Mu were popular among budo practitioners. The Heart Sutra, with 262 characters, was much too long and complicated to chant. Even mantras such as Na-mu-myo-ho-ren-ge-kyo and Na-mu-a-mi-da-butsu take a few seconds to recite. On the battlefield there is only time for a single shout—and it is a matter of life or death. This one-word barrier seems to be floating in space, a bit off-center, suggesting that Mu is not a concept that can be pinned down. The gap between the character and Tesshu's signature is also intriguing: How should the viewer bridge it?

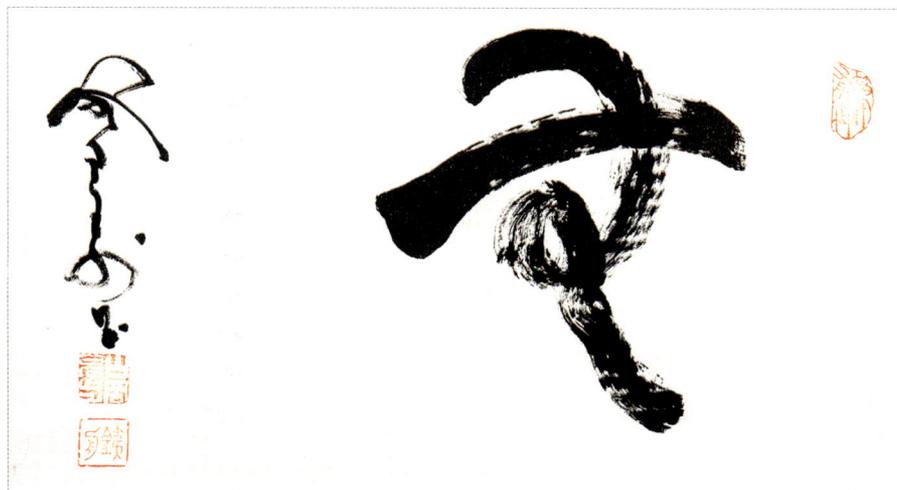

TWO-CHARACTER CALLIGRAPHY

Mu-i

Tesshu Koho brushed [this]

Mu-i (*wu wei* in Chinese, 無為) is a key concept in Daoism, Zen, and the martial arts. It has many possible interpretations: "nondoing," "nonaction," "without effort," "no-control," and so on.

As is the case with many of Tesshu's large calligraphies of one to three characters, the brushwork seems to be floating off the paper.

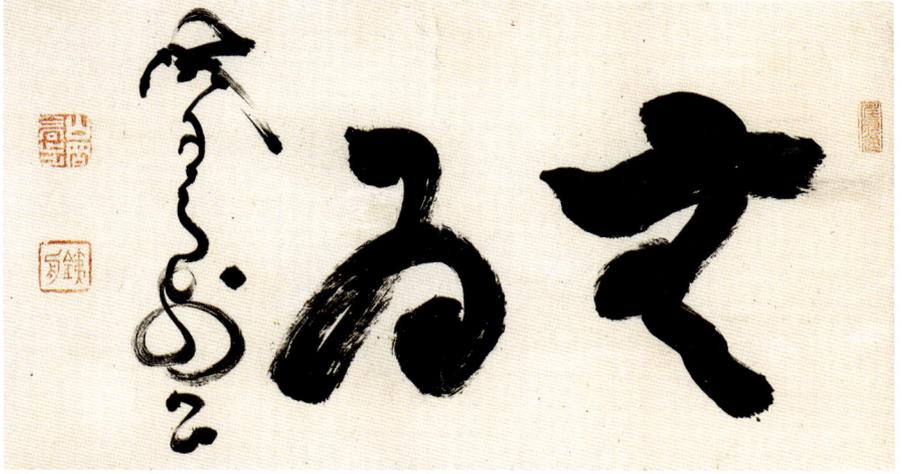

TWO-CHARACTER CALLIGRAPHY

Buji

Tesshu Koji brushed [this]

Buji (無事) literally means "nothing happens (or happened)." It can also be used in the sense of there being "no trouble," or "everything is undisturbed." Another meaning of *buji* is "not causing trouble" for oneself or others. *Buji* is the prime Zen virtue. In the martial arts context, it means "No one got hurt," or "Everyone escaped." The brushwork here is bold and dynamic. It makes a strong statement.

Normally, art collectors want the items they acquire to be in excellent condition. Because Zen scrolls were often hung for decades, even centuries, many are in "bad" condition—tanned by sunlight and smoke from a hearth, on cheap paper with shabby mounting, creased, cracked, flaking, spotted, torn, replete with wormholes, barely hanging together. However, from a Zen perspective, the disintegration and/or discoloration of the paper, the missing patches of text, the blotches, the cracks, and the other "imperfections" actually become an essential aspect of the art. The message is "If a zenga is in perfect condition, good; if not, better." In Japan, dealers will sometimes charge more money for a piece in its original condition—even one half-burned in a fire—than for one that has a spanking new mounting. If a zenga is hanging by a thread, it is still in "one piece."

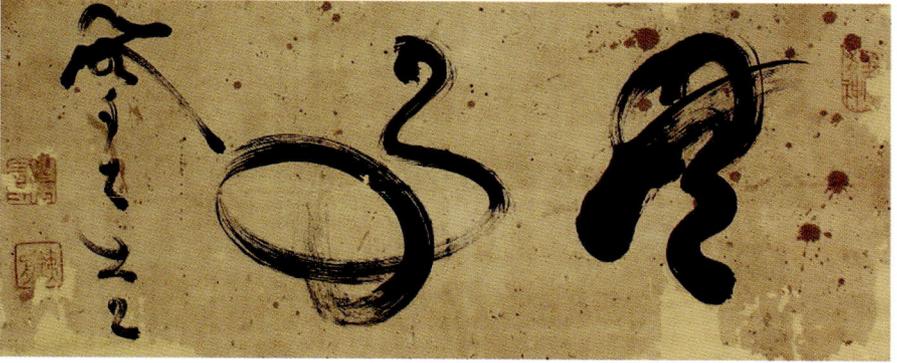

TWO-CHARACTER CALLIGRAPHY

Sit and forget

Tesshu Koho brushed [this]

The two characters 坐忘 mean "sit" in meditation and "forget" every-thing—mind and body, self and other, past, present, and future. It is a term employed by both Daoists and Buddhists to describe a state of being that is perfectly natural and tranquil. The brushwork here is dynamic and powerful; "sit and forget" is not advice, it is an order!

This is a splendid example of Tesshu's mature brushwork: rich, deep, and lucid.

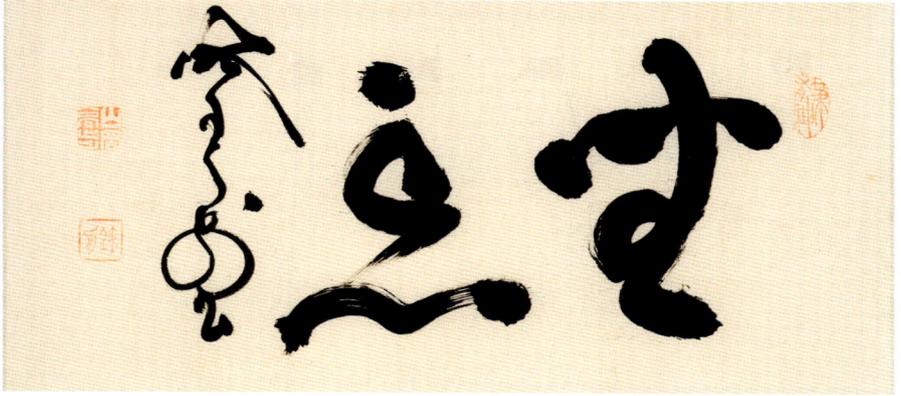

CALLIGRAPHY

Fuku

Roku

Ju

Brushed for Mr. Nakano by Tesshu Koho

Fuku (福), or "wealth," *Roku* (禄), or "good fortune," *Ju* (壽), or "longevity," is one of the Seven Lucky Gods. He is depicted in the dress of a Chinese hermit, with an elongated forehead that frequently extends into a clearly phallic shape and a squat body that resembles a scrotum. Painted images of Fukurokuju are often accompanied by saucy double entendre inscriptions, and statues of him are widely displayed as fertility gods. Calligraphy of the three characters, as in this example, is more of a graphic good luck charm, although there is still an erotic element to the name. Fukurokuju calligraphy was a favorite theme for Tesshu, and many people such as the Mr. Nakano mentioned here petitioned him for a specimen. The brushstrokes of the three characters swirl down the paper in an impressive manner.

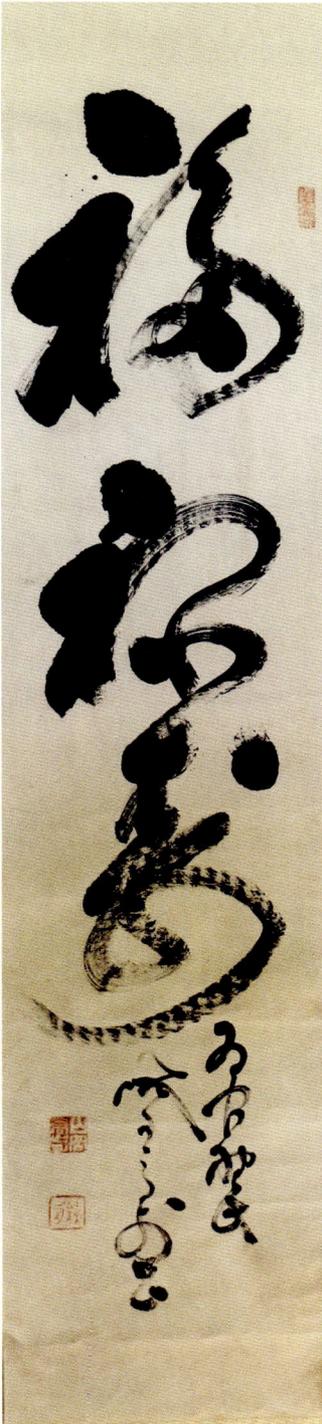

HORIZONTAL CALLIGRAPHY

Harmony, Respect, Purity, Tranquility
Year of the Metal Snake, seventh month [1877]
Brushed at Zensho-an by Tesshu Koji

Harmony, respect, purity, tranquility (*wa kei sei jaku*, 和敬清寂) are the four virtues of the tea ceremony and, indeed, of daily living itself. This was brushed at Zensho-an, the temple Tesshu established as a memorial for all those who had perished in the fighting during the Meiji Restoration.

和为贵室

ONE-LINE CALLIGRAPHY

On whose gate does the bright moon not shine?

Brushed at the request of Mr. Yamada Matashichiro by Tesshu Koji

There is nowhere the bright moon of enlightenment does not shine. No matter who or where you are, it is possible to practice Zen and attain awakening.

ONE-LINE CALLIGRAPHY

A breeze gently blows through the library window;
moonlight floods the room.

Tesshu Koho brushed [this]

This refers to a refined Confucian gentleman reading quietly by moonlight in his tastefully decorated house (rather than a Daoist immortal tipsy on wine under plum blossoms). The meaning is not particularly deep, but the brushwork is elegant and perfectly composed.

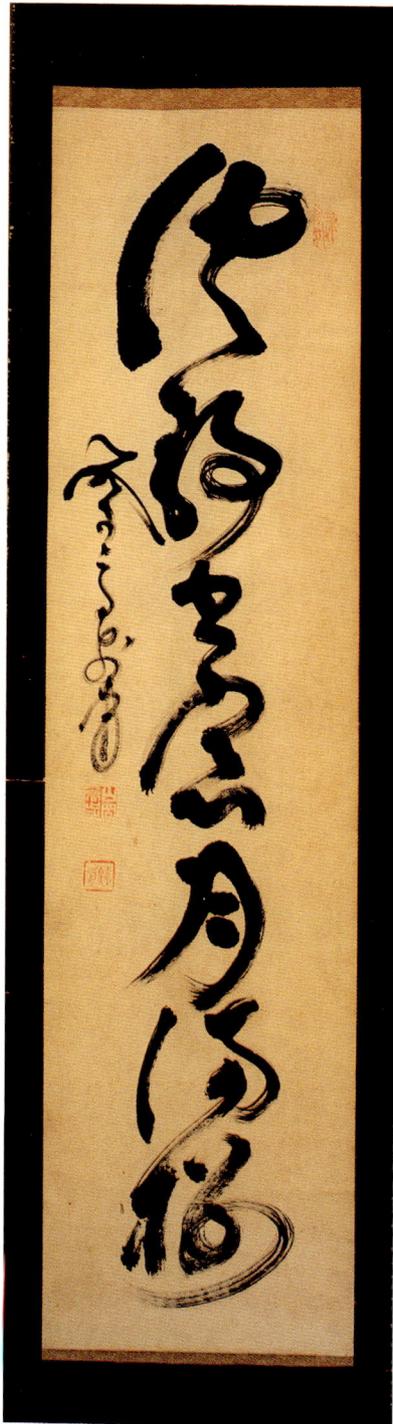

ONE-LINE CALLIGRAPHY

In heaven and earth there is no "I"; that is why we love others!

Fourth Imperial Rank Yamaoka Tetsutaro brushed [this]

This is a saying of Nakae Toju (1608–1648), an enlightened Neo-Confucian philosopher who was known as the Saint of Omi Province. Nakae practiced what he preached, treating others as equals and companions without regard to their social status. This principle was also a guiding light for Tesshu, famous for his Buddhist generosity and his ability to associate freely with anyone, from emperor to beggar.

AMIDA MYOGO

Hail to Amida Buddha!
(Namu Amida Butsu)
Fourth Imperial Rank Yamaoka Tetsutaro brushed [this]

In East Asian Buddhism, Amida, the Buddha of the Pure Land, is the most venerated. This buddha made a vow to save everyone. The chant Namu Amida Butsu is a supplication, an expression of gratitude, a magic charm.

Even though Zen (self-power) and Pure Land (other power) seem to be at opposite ends of the Buddhist spectrum, both have the same ideal: finding Buddha within one's heart without depending on an elaborate superstructure. This myogo by Tesshu is extraordinary powerful. It was brushed with one full charge of ink in a tremendous burst of energy. (The design at the bottom is a lotus blossom.)

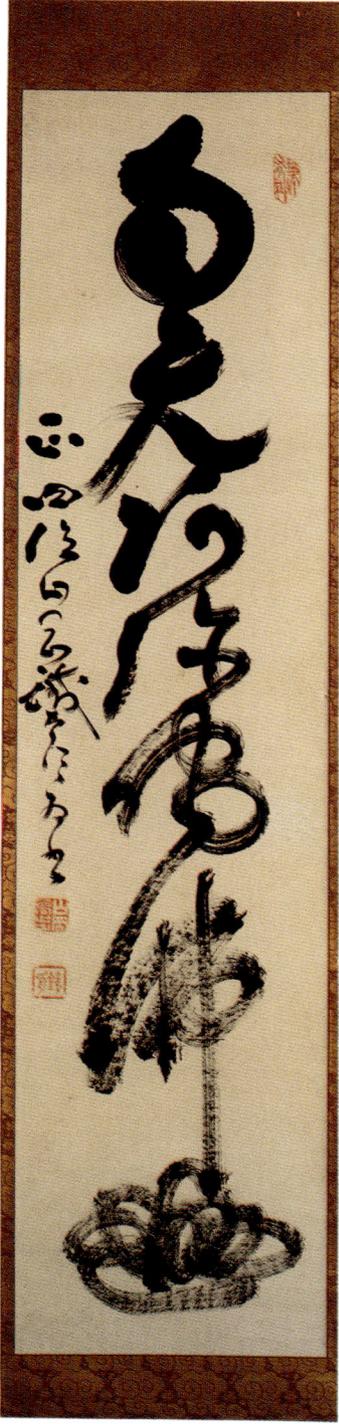

LOTUS SUTRA MYOGO

Na Mu Myo Ho Ren Ge Kyo

Fourth Imperial Rank Yamaoka Tetsutaro respectfully brushed [this]

Here is Tesshu's version of the Nichiren myogo. Deishu's brushwork (see page 92) is more low-key, while Tesshu's feels like it is going to leap off the paper. The calligraphy seems to be telling us, "Watch it! Get out of my way!"

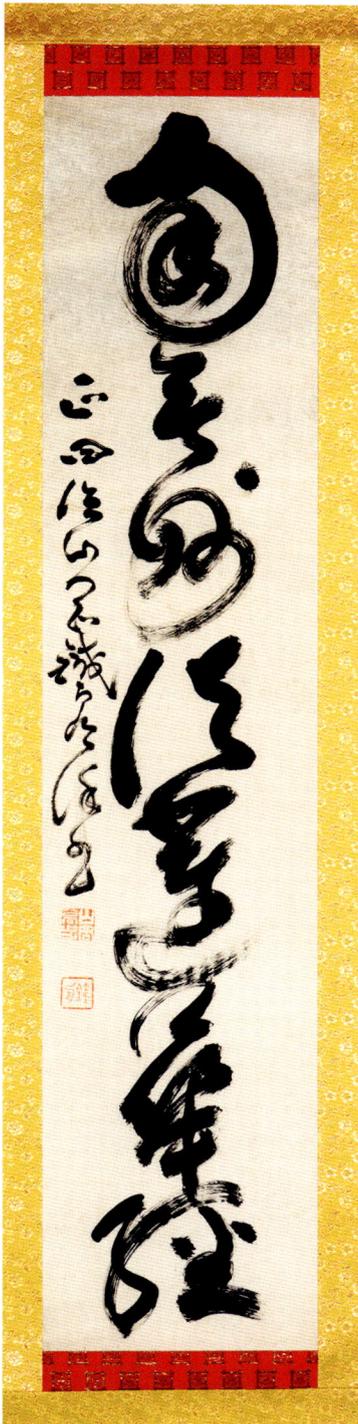

MYOGO

Moon Sun

Mount Fuji [painting]

ASAMA OKAMI

Fourth Imperial Rank Yamaoka Tetsutaro respectfully brushed [this]

Mount Fuji itself is held to be divine. It is also a volcano—it last erupted in 1707—and one theory is that *asama* is the Ainu word for "volcano." Asama Jinja was established at the base of Mount Fuji in 806. When women were prohibited from ascending to the summit, Asama Jinja was as far as they were allowed to climb. The shrine eventually expanded into a huge compound to handle all the pilgrims, and as noted, the surrounding caves were used for worship of various kinds. Since the goddess enshrined on Fuji is Konohanasakuya-hime (Princess Cherry Blossom), the *jinja* grounds are adorned with more than five hundred sakura trees, making for a spectacular scene in spring. Over the centuries, many groups of "asama worshippers" organized prayer meetings, pilgrimages to the top of the mountain, and other events.

Tesshu brushed this myogo, on inexpensive paper provided by a poor pilgrim, to hang in the family altar space. The brushwork is more numinous Shinto than dynamic Zen.

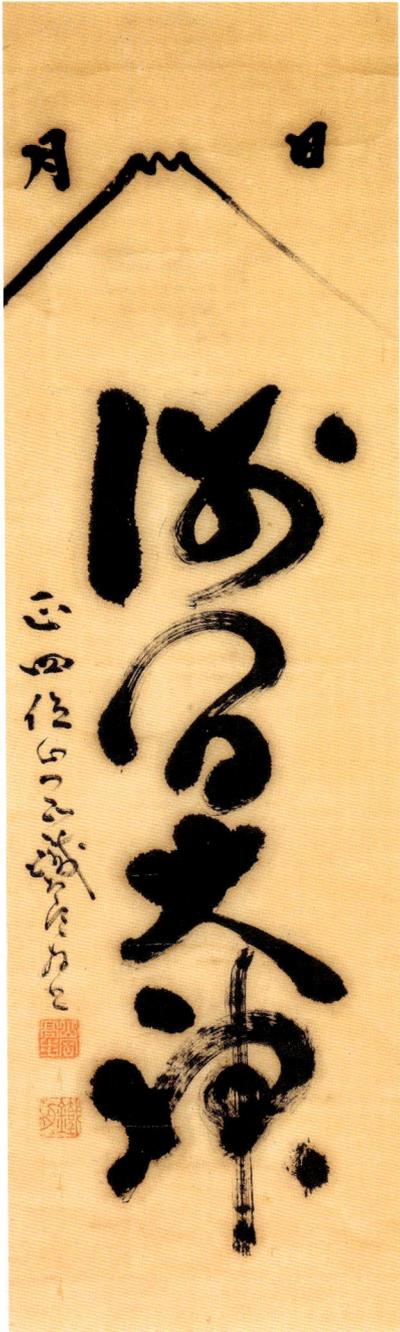

TWO-LINE CALLIGRAPHY

Sit beneath the white clouds and crimson leaves,
And offer a song of tranquility.

Tesshu Koji brushed [this]

The brushwork here flows smoothly up and down the paper. The characters within the two columns give the impression of being a single integrated piece of calligraphy.

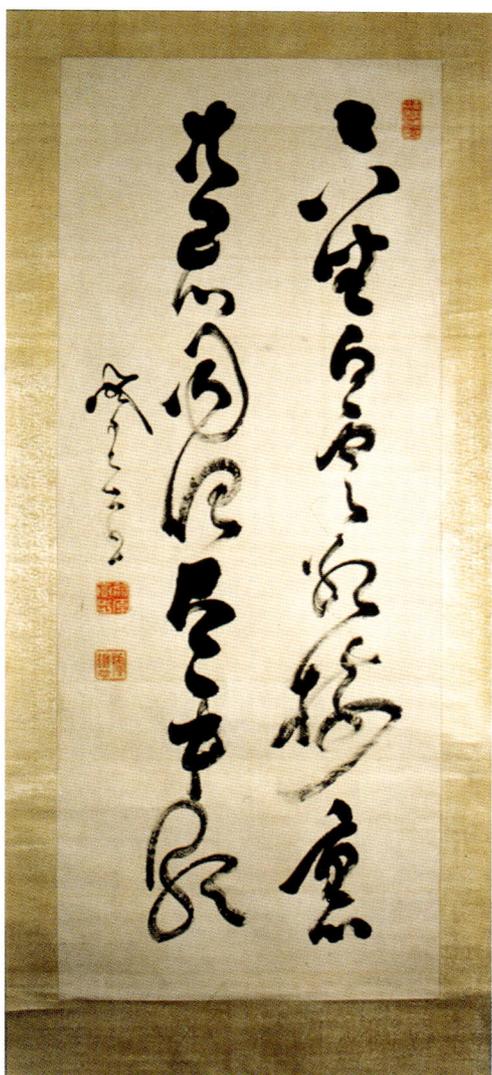

CALLIGRAPHY OF *EIGHT IMMORTALS OF THE WINE CUP* COMPOSED BY TU FU

Chu-chang sways to and fro on his horse
 as if he were on a reeling ship;
Should he fall bleary-eyed into a well,
 he would probably fall fast asleep on its bottom.
Ju-yang the prince needs three gallons
 first thing in the morning;
How his mouth waters when the brewer's cart passes by;
 too bad he can't be Lord of the Wine Spring.
Li the minister spends thousands to indulge his daily habit,
 gulping rivers of wine like a great whale.
Cherishing his cup, he takes pleasure in his wisdom water
 while promising to retire from office as soon as he can.
Tsung-chi is a handsome youth
 who disdains the base;
Holding his beloved cup, he fixes his gaze on heaven,
 resplendent as a jade tree in a gentle wind.
Su Chin the monk
 chants before the Buddha image
But often breaks off his meditation
 to go on a spree.
Li Po gets a hundred poems out of one gallon;
 he naps in a wine shop in Chang-an.
Refusing to board the Imperial Barge when the emperor beckons:
 "Please, Your Majesty, I am an Immortal of Wine."
Chang Hsu the renowned calligrapher has three cups
 and he is ready to go;
Ignoring court etiquette, he removes his hat
 and dashes off a masterpiece.

Chao Sui downs five gallons
 and fills the banquet hall
With marvelous speech,
 his eloquence the wonder of all.
Tesshu Koji brushed [this]

飲中八仙歌

知章騎馬似乘船
眼花落井水底眠
汝陽三斗始朝天
道逢麴車口流涎
恨不移封向酒泉
左相日興費萬錢
飲如長鯨吸百川
銜杯樂聖稱避賢
宗之瀟灑美少年
舉觴白眼望青天
皎如玉樹臨風前
蘇晉長齋繡佛前
醉中往々愛逃禪
李白一斗詩百篇
長安市上酒家眠
天子呼來不上船
自稱臣是酒中仙
張旭三杯草聖傳
脱帽露頂王公前
揮毫落紙如雲煙
焦遂五斗方卓然
高談雄辨驚四筵

Tesshu brushed this masterpiece of calligraphy when he was about forty-six. The placement of the characters and the spacing of the lines are perfect, and a Zen zip propels the brushwork from start to finish. (In the printed version given here, the characters, read from the left, are placed horizontally for reasons of space.)

陶八仙歌

李白斗酒诗百篇，长安市上酒家眠，天子呼来不上船，自称臣是酒中仙。

张旭三杯草圣传，脱帽露顶王公前，挥毫落纸如云烟。

焦遂五斗方卓然，高谈雄辩惊四筵。

戊寅方寅父于从政楼海堂

A HUNDRED BATTLES

One hundred victories in one hundred battles is not equal
 to one act of patience;
Ten thousand clever words are not as good as a single silence.

Tesshu Koji

There are hundreds of precepts in Buddhism, but most important is patience, being able to "bear the unbearable" and to overcome all the obstacles in life. Nothing great is accomplished without constant effort and patient behavior. Flowery speech may be impressive, but it is not equal to a moment of silence, a knowing silence that says it all.

百戰百勝非一勇萬言萬當不如一默

ENSO (DETAIL)

The enso is the timeless circle. The first known Zen painting was an enso, brushed by an eighth-century Chinese master for one of his disciples as a visual aid for the understanding of Zen. Ever since then, the enso has been a primary teaching tool in Zen practice. An enso is perfectly abstract and minimalist, subjective and objective, instructive, inspiring, and enlightening, regardless of whether it was brushed a thousand years ago or yesterday. An enso is not brushed; unfolds. One has to *be* the enso, letting it unfold—nothing is created, there is no artist/art. This enso by Tesshu seemingly emerges out the void and looks as if it is slowly rotating.

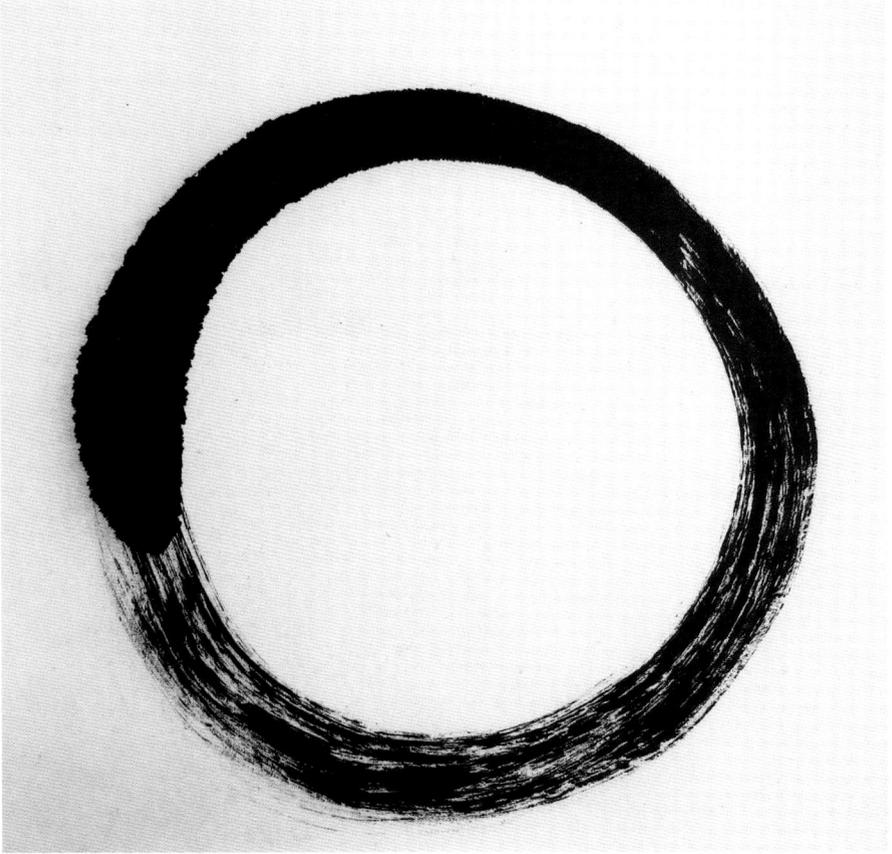

HEART SUTRA

The Bodhisattva of Compassion, moving in the deepest wisdom, clearly saw that the five fields are void and thus passed over all suffering and distress. O Shariputra, Form is not different from Emptiness, Emptiness is not different from Form; Form is Emptiness, Emptiness is Form. Feeling, thought, volition, and consciousness are all like this. O Shariputra, all things are void: they have no birth, no death, no taint, no purity, no increase, no decrease. Hence, in the void there is no form, no feeling, no thought, no volition, no consciousness, no eyes, no ears, no nose, no tongue, no body, no mind; no color, no sounds, no smell, no taste, no touch, no intellect; no realm of sight right through no realm of consciousness; no ignorance and no extinction of ignorance; no old age and no death and no extinction of old age and death: no suffering, no craving, no loosening, and no path; no wisdom and no attainment. With nothing to gain, bodhisattvas use great wisdom with their minds free of hindrance. Free of hindrance, there is no fear. Far beyond delusive views, nirvana appears. All buddhas of the three worlds thus use great wisdom and thus attain supreme enlightenment. Therefore, know that the great wisdom here is the most divine mantra, the brightest mantra, the highest mantra, the incomparable mantra that allays all suffering. This is the Truth, not Falsehood! So proclaim the great wisdom mantra, proclaim the mantra like this: Gone, Gone, Gone Beyond, Gone Completely Beyond, Awakening Right Now!

Fourth Imperial Rank Yamaoka Tetsutaro respectfully brushed [this]

般若波羅密多心経

観自在菩薩行深般若波羅密多時照見五蘊皆空渡一切苦厄舎利子色

不異空々不異色々即是空々即是色受想行識亦復如是舎利子是諸

法空相不生不滅不垢不浄不増不減是故空中無色無受想行識無眼耳

鼻舌身意無色聲香味触法無眼界乃至無意識界無々明亦無々明尽

乃至無老死亦無老死尽無苦集滅道無智亦無得以無所得故菩提薩

埵依般若波羅密多故心無罣礙無罣礙故無有恐怖遠離一切顛倒夢想究竟

涅槃三世諸佛依般若波羅密多故得阿耨多羅三藐菩提故知般若

波羅密多是大神呪是大明呪是無上呪是無等々呪能除一切苦真實不

虚故説般若波羅密多呪即説呪曰羯諦羯諦波羅羯諦波羅僧羯諦

菩提薩姿訶般若心経　　正四位山岡鐵太郎拝書

The Heart Sutra is magic. Hundreds of commentaries have been, and continue to be, written on its contents. The commentaries range from the arcane to the ponderous, some of them hundreds of pages in length, but all of them have one thing in common—they are invariably too wordy and schoolmarmish. The entire point of the Heart Sutra is that there is no point. That's what the Heart Sutra is telling us: there is no way you can explain it in words. The Heart Sutra works best as a vibrant invocation or brushed as a talismanic calligraphy, as in this masterpiece by Tesshu. It is a unified whole, not a gathering of individual characters.

般若波羅蜜多心經

觀自在菩薩行深般若波羅蜜多時　照見五蘊皆空　度一切苦厄　舍利子　色不異空　空不異色　色即是空　空即是色　受想行識亦復如是　舍利子　是諸法空相　不生不滅　不垢不淨　不增不減　是故空中無色　無受想行識　無眼耳鼻舌身意　無色聲香味觸法　無眼界　乃至無意識界　無無明　亦無無明盡　乃至無老死　亦無老死盡　無苦集滅道　無智亦無得　以無所得故　菩提薩埵　依般若波羅蜜多故　心無罣礙　無罣礙故　無有恐怖　遠離顛倒夢想　究竟涅槃　三世諸佛　依般若波羅蜜多故　得阿耨多羅三藐三菩提　故知般若波羅蜜多　是大神咒　是大明咒　是無上咒　是無等等咒　能除一切苦　真實不虛　故說般若波羅蜜多咒　即說咒曰　揭諦揭諦　波羅揭諦　波羅僧揭諦　菩提薩婆訶　般若波羅蜜多心經

Resources

Addiss, Stephen. *The Art of Zen: Paintings and Calligraphy by Japanese Monks 1600–1925*. Brattleboro, VT: Echo Point Books & Media, 2019.

Addiss, Stephen, and G. Cameron Hurst III. *Samurai Painters*. New York City: Kodansha International, 1983.

Sato, Hiroaki. *Legends of the Samurai*. New York City: Harry N. Abrams, 2012.

Sogen, Omori, and Terayama Katsujo. *Zen and the Art of Calligraphy: The Essence of Sho*. Translated by John Stevens. London: Routledge, 1983.

Stevens, John. *Budo Secrets: Teachings of the Martial Art Masters*. Boston, MA: Shambhala Publications, 2002.

Stevens, John, and Felix Hess. *Seeing Zen*. Warren, CT: Floating World Editions, 2019.

Sugawara, Makoto. *Lives of Master Swordsmen*. Tokyo: East Publications, 1985.

Woodson, Yoko. *Lords of the Samurai: The Legacy of a Daimyo Family*. San Francisco: Asian Art Museum, 2017.

Zorn, Bettina, ed. *The Elegance of Hosokawa: Tradition of a Samurai Family*. Munich: Hirmer Publications, 2021.

Artist Biographies and Reading Lists

..

Awa Kenzo 阿波研造 (1880–1939)

Kenzo was born in Miyagi prefecture. Not much is known about his childhood. He was an autodidact, opening the Academy of Chinese Learning in 1897, at the precocious age of eighteen. In 1899, Awa moved to the port city of Ishinomaki to marry Awa Fusa and be adopted into the Awa family. It was in Ishinomaki that Awa began the practice of kyudo, traditional Japanese archery. He also familiarized himself with other martial arts—sword fighting, jujutsu, spear fighting, and so on.

In 1902, Awa opened his own dojo, offering instruction in kyudo, kendo, jujutsu, *naginata*, and other martial arts. In 1909, Awa, his wife, and his five-year-old daughter moved to the capital city of Sendai. There, Awa opened a kyudo dojo, but with the introduction of Western culture, martial arts held little appeal for the young people of the early Meiji period. Times were tough. Nonetheless, Awa established a reputation as a "one hundred shots, one hundred bull's-eyes" archer and was widely held to be one of the best shooters in the country. He finally gained employment as a kyudo instructor at the Second High School and opened a new dojo in 1918. Thereafter, Awa devoted himself to fathoming the true meaning of the Way of the Bow. He began practicing Zen under the direction of Banryu, the abbot of Zuigan-ji in Matsushima. Awa realized that the "bow and Zen are one." He taught his disciples, "See into your Buddha-nature with a single shot."

The German philosopher Eugen Herrigel, who was teaching at Tohoku University, trained with Awa from 1924 until 1929. He composed the book *Zen and the Art of Archery* based on his experiences with Awa Sensei. The book has remained an international bestseller since its publication in 1948.

In 1929, Awa fell gravely ill with kidney disease. Given a year to live, he managed to continue shooting one or two arrows every day, even at his

worst. In 1938, Awa's condition deteriorated, and he died on March 1, 1939, at sixty years of age.

Herrigel, Eugen. *Zen in the Art of Archery*. New York City: Vintage Books, 1971.

Stevens, John. *Zen Bow, Zen Arrow: The Life and Teachings of Awa Kenzo, the Archery Master of Zen in the Art of Archery*. Boston, MA: Shambhala Publications, 2007.

DEGUCHI ONISABURO 出口王仁三郎 (1871–1948)

Onisaburo was one of the most charismatic, eccentric, and controversial figures of twentieth-century Japan. He was born as Ueda Kisaburo in Kameoka Ciy near Kyoto. Onisaburo was the leader of Omoto-kyo, a spiritual movement that attracted followers all over the globe. He was a shaman, healer, miracle worker, artist supreme, standup comedian (his jokes made the supreme court judges pondering his fate laugh), martial artist, and soothsayer. Onisaburo emphasized that "art is the mother of religion; art is religion."

Onisaburo was an unbelievably prolific artist, rivaling Tesshu in the number of works he created. He produced hundreds of thousands of items: paintings, calligraphies, talismans, poems, songs, dances, cinema, even operas. Onisaburo's "scintillating tea bowls" (*yowan*) are considered to be among the most creative and beautiful of any ceramics made in the modern era. Flamboyant Onisaburo decked himself out in costumes of fabulous design and texture, often dressing as a variety of Shinto or Buddhist deity or in drag. He practiced kyudo and several occult martial arts. Onisaburo spent a total of six and a half years in prison for his anti-government agitation, and he stayed in remarkably good humor throughout his imprisonment. (It is reported that he masturbated every day.) He was freed from prison at the end of World War II in 1945. Onisaburo refused to seek reparations from the government, saying that the money would actually come from taxes on the struggling citizens. After a long and tumultuous career, Onisaburo "ascended to heaven" on January 1, 1948, at age seventy-six.

Deguchi, Kyotaro. *The Great Onisaburo Deguchi*. Sioux Falls, SD: Aiki News, 1998.

Deguchi, Onisaburo. *The Art of Onisaburo Deguchi (1871–1948) and His School; Ceramics, Paintings, Calligraphy, and Paintings*. Kyoto, Japan: Oomoto Foundation, 1975.

HAKUIN EKAKU 白隠慧鶴 (1685–1768)

Born in Hara, Hakuin entered Shoin-ji, the local Zen temple, in his mid-teens. During the following decades, he had many varied and intense experiences. He was either in a state of ecstatic enlightenment or suffering from a nervous breakdown. He wrote that he nearly died from "Zen sickness." Hakuin finally settled at his home temple of Shoin-ji to begin a long and memorable teaching career. He established the modern Rinzai koan training system and taught hundreds of monks, nuns, samurai, and laypeople.

Hakuin was a talented and prodigious Zen artist. He kept up an exhausting round of public talks, individual and group instruction, meditation, and brushwork right up until his death in 1768. He is considered the most outstanding Rinzai Zen priest of the last five hundred years. After being bedridden for a few days, Hakuin sat up, gave a roar u-u-n! (Japanese pronunciation for OM), and passed away.

Addiss, Stephen, and Audrey Yoshiko Seo. *The Sound of One Hand: Paintings and Calligraphy by Zen Master Hakuin*. Boston, MA: Shambhala Publications, 2010.

Tanahashi, Kazuaki. *Penetrating Laughter: Hakuin's Zen and Art*. New York City: Overlook Press, 1984.

HIRAYAMA SHIRYU 平山子龍 (1759–1828)

Shiryu was born in Edo. He was a real hard-core samurai: he never wore more than one cotton robe, summer or winter; he lived on brown rice, miso soup, vegetables, and pickles; he slept on one quilt in the corner of his dojo; he rose at 4 a.m. to practice a wide variety of martial arts; he swung a heavy staff five hundred times and then made between 200 and 250 draws of the sword to warm up. For the rest of the day, he studied

Confucian classics and military manuals. As he read, Shiryu would crush unhulled chestnuts and repeatedly punch and stab a wooden board placed on his desk to toughen his fists and fingers. His house was jam-packed with all sorts of weapons: long swords, regular swords, wooden swords, bamboo swords, daggers, spears, naginata, staffs of various lengths, iron rods, bows, containers full of arrows, two full sets of armor, a crate of miscellaneous smaller weapons, muskets, and two cannons. A keg of sake was kept in a closet, and hundreds of books were scattered everywhere. Shiryu never married.

His calligraphy was an extension of his budo practice—he let out a terrific shout just before picking up the brush and sprayed the room with ink when he wrote. His brushwork is no-nonsense, devoid of flourishes.

Sogen, Omori, and Terayama Katsujo. *Zen and the Art of Calligraphy: The Essence of Sho*. London: Routledge, 1983.

Ishikawa Jozan 石川丈山 (1583–1672)

Ishikawa Jozan was born into a samurai family in Mikawa province; both his grandfather and father were noted warriors. Jozan learned martial arts from the age of three and went on to serve under the first Tokugawa Shogun Ieyasu. For various reasons, Jozan withdrew from samurai service in his midthirties to become a scholar and man of letters. It is said that Jozan attacked books the same way he used to attack enemies—mowing down volume after volume. In 1641, at the age of fifty-nine, Jozan built the hermitage Shisendo, one of the most enchanting buildings in Japan, and designed the breathtakingly beautiful gardens and grounds. He remained unmarried and lived as a recluse, devoting the rest of his long life to studying the classics, poetry composition, the practice of *sencha* (Chinese-style tea ceremony), garden design, and calligraphy. He remained a samurai at heart, always wearing his sword whenever he went out; at home, a sword was always near at hand. In fact, Jozan was thought to be a ninja, since he always kept on hand an emergency supply of pickled plums, a ninja food that provides salt to one's diet, fosters stamina, and staves off hunger. He wrapped padding around his chest to protect against knife attacks and had a specially made *shuriken* concealed in his clothing.

Although supposedly a hermit, Jozan had a wide circle of influential acquaintances who enjoyed dropping by Shisendo to "gossip," or exchange information. Jozan was an antiquarian and developed a distinctive style of calligraphy based on ancient Chinese clerical script. Jozan is counted as one of the Japanese Gods of the Brush.

Rimer, J. Thomas, Stephen Addiss, Hiroyuki Suzuki, et al. *Shisendo: Hall of the Poetry Immortals.* New York City: Weatherhill, 1991.

ITO JAKUCHU 伊藤若冲 (1715–1800)

Jakuchu was born as the scion of a prosperous greengrocer shop in Kyoto. He preferred painting to dealing with vegetables, so he eventually turned the business over to his younger brother and opened a studio called Shin'enkan on the bank of the Kamo River. Jakuchu had an extraordinarily wide range of painting styles, from the most incredibly detailed paintings of birds, flowers, and exotic animals to delightful zenga created with a few monochrome strokes. His masterpiece is *Vegetable Nirvana*, with a giant daikon serving as Buddha, surrounded by a garden of vegetable mourners.

One of the most popular artists of the time, Jakuchu was flooded with commissions from private individuals to huge headquarter temples. Despite his commercial success, he lived simply as a lay monk, practicing Chinese-flavored Obaku Buddhism, a mixture of Amida chanting and Zen meditation. Jakuchu viewed the world not as a professional artist but as a Buddhist visionary. He became a recluse in his final years. He called himself the "Bushel Monk" because he exchanged paintings for a bushel of rice. (He no longer needed lucre at that stage.) He passed away peacefully in 1800.

Hickman, Money L. *The Paintings of Jakuchu.* New York City: Henry N. Abrams, 1989.

IZAWA DEIRYU 井沢泥龍 (1895–1954)

Deiryu was born into a military family from Wakayama prefecture. As a young monk, he was an attendant of Nantenbo. Unlike most Zen artists, who don't hit their stride until their later years, Deiryu was a talented and

prolific artist from an early age, starting in his twenties. (When Nantenbo accused him of copying the former's work and selling it, Deiryu replied, "Why would I do that? My brushwork is much better than yours!") Deiryu produced many fine pieces in his relatively short life. As the abbot of Enpuku-ji for many years, he was a master of numerous arts—Zen, calligraphy, painting, the tea ceremony, kendo, and kyudo.

Seo, Audrey Yoshiko. *The Art of Twentieth-Century Zen: Paintings and Calligraphy by Japanese Masters*. With Stephen Addiss. Boston, MA: Shambhala Publications, 1998.

KANO JIGORO 嘉納治五郎 (1860–1938)

Kano was born to a prosperous sake-brewing family in what is now Kobe. His father arranged for him to receive an excellent education, with many well-known scholars as his tutors. After his mother died when Kano was nine years old, his father moved the family to Tokyo. Kano continued his studies at various private academies, a couple of them run by Europeans, and became fluent in English and German. Kano entered Tokyo Imperial University, Japan's premier educational institution in 1874. Studious, slight of build, and from a privileged family, he was ruthlessly bullied by his classmates. Like many bullied children everywhere, Kano decided to do something about this sorry state of affairs by learning self-defense. After much searching, he found a few old masters of jujutsu—at that time considered old-fashioned and dangerous—to teach him. Kano threw himself into training in several different styles, primarily Tenjin Shin'yo Ryu and Kito Ryu.

Based on his experiences, Kano developed a composite system he termed *judo*, the "Gentle Way." In the spring of 1882, at age twenty-two, Kano established the Kodokan Judo Institute with a handful of students. Eventually, Kodokan judo spread worldwide to include millions of practitioners. Kano is also venerated as an educator; a long-time president of the Tokyo Teachers College; a member of the Japanese Diet; a statesman; and a promoter of the Olympic Games, which he called an "event that would bring the world closer together." He was one of the most influential figures of the twentieth century, both at home and abroad. Tirelessly trav-

eling the globe to spread his ideas, Kano died halfway home on a solitary voyage from the United States to Japan in May 1938.

Stevens, John. *The Way of Judo: A Portrait of Jigoro Kano and His Students.* Boston, MA: Shambhala Publications, 2013.

Katsu Kaishu 勝海舟 (1823–1899)

Kaishu was born in Edo, son of the infamous Katsu Koichiro, the ne'er-do-well samurai whose outrageous behavior is described in his autobiography translated into English as *Musui's Story.* Koichiro was so dissipated that he turned over the family headship to his fifteen-year-old son. Kaishu worked tirelessly to restore honor to his family by paying off his father's many debts. When he was sixteen, Kaishu entered the dojo of Shimada Toranosuke, who told him, "If you want to master kendo, study Zen." In the evening after training, Kaishu alternated swinging a wooden sword with zazen sitting on a rock. He then practiced Zen full-time at Kofuku-ji in Tokyo for nearly four years.

Kaishu went on to become one of the architects of modern Japan. He was a swordsman; a scholar (he divided his study time between Japanese, Chinese, and Western classics); a mediator (he negotiated the peaceful end to the civil war, saving countless lives and preventing the destruction of Edo); the father of the Japanese navy; a diplomat (he was commander of the first official delegation to the United States); and in his later years, an influential advisor to the Meiji government and other associations (such as Kano's Kodokan Judo Institute). Although more than twenty attempts were made on his life by fanatic samurai and his political opponents, Kaishu survived them all by either outwitting his assassins or talking his way out of danger. He said, "Only an inferior swordsman needs to draw his blade; the most skillful swordsman is one who never has to use his weapon." In the violent times of the Boshin War, Kaishu was proud he never took another's life; "That is the mark of a true samurai," he said. On his deathbed, his final words were, "That's it for me."

Hillsborough, Romulus. *Samurai Revolution: The Dawn of Modern Japan Seen Through the Eyes of the Last Samurai.* Rutland, VT: Tuttle Publishing, 2014.

Matsuo Basho 松尾芭蕉 (1644–1694)

Revered worldwide as the father of haiku, Basho was born into a major ninja family in Iga-Ueno. Following family tradition for members of a ninja household, Basho received extensive ninja training. When he was thirteen, he went to serve in Iga-Ueno Castle under Todo Shinchichiro Yoshitada, head of the Todo clan. Yoshitada (pen name Sengin) was Basho's first poetry teacher. After Sengin died suddenly at age twenty-five, Basho left Iga-Ueno to pursue his study of haiku. He later attracted many students, and his haiku were highly praised. He compared his composition of haiku to a *kiai*, an explosive martial art shout.

Basho's mark on the development of haiku is immeasurable. He traveled widely and published a number of poetic travel journals based on his many trips. His greatest journey, recorded in *Oku no Hosomichi* (*Narrow Road to the Deep North*), conducted over a five-month period in 1689, was not merely to sightsee, compose haiku, and visit literary acquaintances. It was also an intelligence gathering mission to spy on the Date Han and survey the area's natural resources—ports, waterways, roads, forests, gold mines, gun powder production, and the like. *Narrow Road to the Deep North* was as much a reconnaissance report as a literary journal. Basho's traveling kit still exists, including a secret drawer containing ninja medicine for emergencies, acupuncture needles, a spyglass, a mini-shuriken, and gold coins. He returned to Iga-Ueno after the trip to be debriefed and prepare his journal for publication. In addition to being a ninja, Basho was openly and proudly gay, boasting of his passion for homosexual encounters. His traveling partners were always young men. Ill and worn out from his travels, Basho died at the early age of fifty in Iga-Ueno.

Matsuo, Basho. *The Narrow Road to the Deep North and Other Travel Sketches.* Translated by Nobuyuki Yuasa. Harmondsworth, UK: Penguin Classics, 1966.

Reichhold, Jane. *Basho: The Complete Haiku.* Tokyo and New York City: Kodansha International, 2013.

Miyamoto Musashi 宮本武蔵 (1584–1645)

Musashi's exact genealogy is obscure, but he was raised as a samurai warrior, which in that violent age meant learning how to kill; he slew an opponent in a duel when he was only thirteen years of age. Musashi was a wild, almost savage figure with unkempt hair and ragged dress, plus he never took a bath. When I asked a senior kendo teacher about this, he remarked, "The dirt on your body can be washed away with a bucket of water, but the dirt in your mind is much harder to remove. Musashi focused on washing away the dirt in his mind." It must be noted that Musashi did, in fact, wash in streams and the ocean where he could not be cornered.

Musashi was victorious in more than sixty contests. At thirty, he realized that even though he never lost a battle, he did not truly understand swordsmanship; he thereupon retired from active fighting to devote himself to further study and practice. Near the end of his life, Musashi was invited to Kyushu by the Kumamoto daimyo Hosokawa Churi. After some years there serving as domain sword instructor, Musashi formulated the principles expressed in his classic *Book of Five Rings* (*Gorin no Sho*). A swordsman nonpareil, an ink painter of the highest standing, a superior calligrapher, an outstanding carver, an excellent craftsman, as well as a poet and writer, Musashi was one of Japan's foremost samurai artists.

Bennett, Alexander, trans. *The Complete Musashi: The Book of Five Rings and Other Works*. Rutland, VT: Tuttle Publishing, 2021.

Tokitsu, Kenji. *Miyamoto Musashi: His Life and Writings*. Translated by Sherab Chodzin Kohn. Boston, MA: Shambhala Publications, 2006.

Wilson, William Scott. *The Lone Samurai: The Life of Miyamoto Musashi*. Boston, MA: Shambhala Publications, 2013.

Nakahara Nantenbo 中原南天棒 (1833–1912)

Nantenbo came from a samurai family based in Karatsu, Kyusu, and was one of the more forceful Zen masters of recent times. He was famed for disciplining his disciples with a staff made from a branch of a *nanten* tree, hence his nickname Nantenbo, or "Nanten-stick." He was a colleague of

the swordsman Yamaoka Tesshu and had many important and influential disciples, a large number from the military. Nantenbo was said to have had more than three thousand Zen students, and he is believed to have created around one hundred thousand works of Zen art. He is much better appreciated in the West than in Japan; his zenga have been widely collected and displayed in Europe and North America.

Seo, Audrey Yoshiko. *The Art of Twentieth-Century Zen: Paintings and Calligraphy by Japanese Masters*. With Stephen Addiss. Boston, MA: Shambhala Publications, 1998.

Nakamura Tempu 中村天風 (1876–1968)

Tempu was born in Tokyo. He began practicing kendo, *iaido*, and judo and studying English in childhood. He had a violent youth—at age sixteen, he killed a rival gang leader. Later he acted as an espionage agent in Manchuria, where he was known as "Killer Tempu" due to his reputation for cutting down bandits. Tempu developed a life-threatening disease, thought to be tuberculosis, at thirty. He traveled the world seeking a cure, which he found when he learned yoga from an Indian guru. Tempu then introduced yoga to Japan. In his midforties, after a successful career as an entrepreneur, he became a spiritual teacher, starting out with soapbox speaking in Ueno and Hibiya parks. Members in his association, the Tempu Kai, eventually numbered in the thousands. Tempu was a popular philosopher who influenced many martial arts, businesspeople, politicians, artists, and writers. A sample of his practical wisdom: "Do not think of work—any work—as a duty. If it is a duty, it will become a burden. How do you turn a burden into a pleasure? Live respectfully, correctly, positively, and boldly." Tempu was an excellent self-taught painter and calligrapher, and his brushwork is still popular and widely collected. Active to the end, he passed away in 1958 at age ninety-two.

Earle, Stephen. *Heaven's Wind: The Life and Teachings of Nakamura Tempu*. Berkeley, CA: North Atlantic Books, 2017.

Nakayama Hakudo 中山博道 (1872–1958)

Nakayama Hakudo was born in Kanazawa in Ishikawa prefecture. He began training in kendo and jujutsu from age eight and then went to Tokyo to enter the famed Yushinkan dojo when he was nineteen. Although short and thin, Hakudo was a demon for training; he flourished under the harsh discipline of the Yushinkan. (Kendo contests there were never timed; a match would continue until one of the combatants conceded.) He eventually took over as head of the Yushinkan. During this period, Hakudo rose at 4 a.m. to do his personal training in the pitch darkness so no one, friend or foe, could see what he was doing. Although he was small—five feet tall and 130 pounds—he was so well grounded that no one, not even the largest sumo wrestler, could knock him off balance with a shove.

Hakudo became one of the premier martial artists of the twentieth century. He held master teaching licenses in kendo, iaido, and jodo. He was a good friend of Kano Jigoro, the founder of judo, and Ueshiba Morihei, the founder of aikido. Hakudo was an excellent calligrapher, who brushed many fine pieces for his disciples and his wide circle of acquaintances. One outstanding aspect of his greatness as a *budoka* was his behavior at the end of the war in 1945. While many military personnel and martial artists committed seppuku upon learning of the disgrace of Japan's surrender to the Allies, Hakudo counseled, "In kendo, we learn to respond appropriately to all kinds of adversity, even defeat. A true swordsman accepts the natural tide of affairs and deals with it. The past is gone, it is what it is. Yesterday, the Allied Army was our enemy, but today they are not. We must be brave enough to be realize that fact with an open mind, a positive attitude, and generosity of spirit and greet our former foe." Nakayama was active in the restructuring of postwar kendo but suffered a stroke in 1950 and was largely incapacitated until his death in 1958.

Okuhara Seiko 奥原晴湖 (1837–1913)

She was born into a high-ranking samurai family in Koga (Ibaraki prefecture). From an early age, she was a tomboy, intent on surpassing all the boys in every endeavor. She didn't care much for book learning, but she

loved the martial arts of jujutsu and sword fighting, eventually being able to defeat all comers, male or female. She also demonstrated extraordinary skill at painting. She studied art under teachers of various schools and made hundreds of sketches of the ancient masterpieces, but eventually she focused on Chinese-style literati painting (*nanga*). When she was twenty-nine, she moved to Edo and assumed the professional name Seiko. She was an almost immediate success as an artist—a painter, calligrapher, and composer of Chinese-style poetry.

Seiko was openly and proudly gay. She sported short hair, mannish clothes, and an in-your-face attitude. (Once when she was a young girl, she tossed an overly aggressive instructor from the second story of his studio. Later on, when a drunken guest at an exhibition opening tried to grab her breasts to see if she was actually a woman, Seiko threw him across the room with a jujutsu technique.) She was a heavyweight, literally and figuratively, in the artistic circles of the time. The talented Seiko became quite wealthy. She was a bon vivant, throwing lavish parties for friends with the best food and drink, usually concluding with a spontaneous painting session. Seiko had many students, said to have numbered around three hundred, including Okakura Tenshin, the author of the classic *The Book of Tea*.

Seiko tired of her life in Tokyo, and in 1891 she moved to a country village in Kumagaya. Despite her isolation, Seiko continued to have many commissions for her paintings, creating many of her finest pieces in her final decade. She remained active until about a year before her death at age seventy-seven. In appearance and behavior, Seiko was the anti-Rengetsu, but if they had lived at the same time, they could easily have become friends.

Fister, Patricia. *Japanese Women Artists 1600–1900*. Laurence, KS: Spencer Museum of Art, 1988.

OTAGAKI RENGETSU 大田垣蓮月 (1791–1875)

Born in Kyoto, Rengetsu, whose birth name was Nobu, is believed to have been the love child of a Todo clan lord and a geiko from the Sanbogi pleasure quarter. She was adopted at birth by Otagaki Teruhisa, a lay official of the Chi'on-in Pure Land sect headquarter temple. In her teen

years, Rengetsu was raised as a samurai lady in nearby Kameoka Castle, well instructed in both the fine and martial arts, including ninjutsu. She was famed for her beauty and married young, but she eventually lost two husbands and all her children (at least four, perhaps as many as six) to illness. She became a Buddhist nun at age thirty-three and thereafter devoted her life to spiritual pursuits; meditation; charity; and art—poetry, calligraphy, painting, and pottery. (Rengetsu supported herself selling handmade ceramics, which are still popular in the antiques trade.) She collaborated with many of the major Kyoto artists and potters of the day. During the violent fall of the shogunate, Rengetsu helped persuade the warriors Saigo Takamori and Yamaoka Tesshu to refrain from further bloodshed. Rengetsu handed the general this poem:

> To those who strike
> And to those who are struck
> Keep in your heart
> That we all are people
> Of the same noble land.

Rengetsu died peacefully at the age of eighty-five in the tearoom of Jinko-in temple in the outskirts of Kyoto.

Eastburn, Melanie, Lucie Folan, and Robyn Maxwell. *Black Robe, White Mist: The Art of the Buddhist Nun Rengetsu*. Canberra: National Gallery of Australia, 2008.

Stevens, John. *Rengetsu: Life and Poetry of Lotus Moon*. Brattleboro, VT: Echo Point Books & Media, 2014.

Saigo Takamori 西郷隆盛 (1827–1877)

Saigo was born in 1827 in Kagoshima, the eldest son of a lower-ranking samurai family. In his youth, he studied Confucianism, practiced the martial arts, and engaged in Zen meditation. However, during an altercation with a bunch of young men, one of the participants drew a sword. Saigo's right elbow was so severely injured when he tried to take the sword that

he was never able to bend it again. Since he could no longer do kendo, he switched to sumo and concentrated more on his book studies.

From a position as a minor domain agricultural official in the backwater of Satsuma, the talented and ambitious Saigo rose to become commander of the Satsuma forces that led the charge to overthrow the Tokugawa shogunate and effect the Meiji Restoration of 1868. As a result of this event, Saigo won a reputation as a great military hero and the universal respect of the samurai who served under him. He was a key figure in the new Meiji government, but his traditional view of samurai culture clashed with the modern innovations proposed by others in the government. Saigo eventually rebelled against the government he had helped create. In 1877 he fell on his sword on the battlefield in Kagoshima in a losing cause. (The government posthumously pardoned him for his rebellion in 1889.)

Saigo, six feet tall and weighing 250 pounds, with huge black eyes, was a giant among his contemporaries, physically and mentally. The large statue in Ueno of a pot-bellied Saigo walking his dog is one of Japan's notable sights. (In an effort to lose weight, he walked eight kilometers a day with his dog.)

Ravina, Mark. *The Last Samurai: The Life and Battles of Saigo Takamori*. Hoboken, NJ: John Wiley & Sons, 2005.

Yates, Charles L. *Saigo Takamori: The Man behind the Myth*. London: Kegan Paul International, 1995.

SAKAI YUSAI 酒井雄哉 (1926–2013)

Sakai Yusai was the amazing Marathon Monk of Mount Hiei, who completed two seven-year, thousand-day kaihogyo. These daily pilgrimages run for periods of one hundred days and range from forty kilometers a day in the first years to sixty kilometers in the middle years and then eighty-four kilometers in the last year. There are also two periods of *do-iri*, nine days of no eating, drinking, sleeping, or resting. The monks are martial artists—they take a suicide vow before setting out on the daily pilgrimage, carrying a knife in case they don't finish the course in the prescribed time and must take their own lives. After fifteen years on the mountain, Sakai retired as an active marathon monk but traveled widely at home and abroad

to spread the teachings of Tendai Buddhism. Despite all his extreme asceticism—or rather because of it—cheerful Sakai become a popular media figure for his easy manner and folksy wisdom. Sakai brushed calligraphies for his many followers and to raise money for charity.

Stevens, John. *The Marathon Monks of Mount Hiei*. Brattleboro, VT: Echo Point Books & Media, 2013.

SENGAI GIBON 仙厓義梵 (1750–1837)

Sengai was born to a peasant family in Mino. A monk at the age of eleven, he set out on a pilgrimage at nineteen. Sengai trained under the master Gessen for thirteen years and began wandering again after his master's death. He ended up in Kyushu, eventually being elected as the abbot of Shofuku-ji, site of the first Zen meditation hall in Japan. Sengai retired from Shofuku-ji when he was sixty-one and spent the rest of his days living in harmony with nature, chatting with visitors, and brushing delightfully eccentric zenga for a host of followers. (Sengai is considered to be the inspiration of manga.) He taught Zen discipline to a number of martial artists. Just before Sengai was ready to pass on at age eighty-eight, he was asked for his final words. He replied, "I don't want to die."

Sengai is the best-known Zen artist in the West. His zenga, regularly displayed in Europe since the 1960s, are widely viewed, studied, and collected.

Furuta, Shokin. *Sengai: Master Zen Painter*. Tokyo and New York City: Kodansha International, 2000.

Suzuki, Daisetsu T. *Sengai: The Zen of Ink and Paper*. Boston, MA: Shambhala Publications, 1999.

SEN NO RIKYU 千の利休 (1522–1591)

Rikyu was born in Sakai, a prosperous port town near Osaka. Early on, he took a keen interest in the *cha-no-yu* (tea ceremony) that was growing in popularity in those days. Rikyu learned cha-no-yu initially from Kitamura Dochin and then from Takeno Jo-o. The ceremony became Rikyu's lifelong vocation. He was also a serious Zen practitioner, mainly under the instruction of Daitoku-ji Zen masters.

Little is known about Rikyu's life during his middle years, but in 1572, at the age of fifty, his reputation was such that he was summoned by successive shoguns, Oda Nobunaga and then Toyotomi Hideyoshi, to serve as tea master. During his years with Hideyoshi, Rikyu revolutionized cha-no-yu. His tradition of *wabi-sabi* tea—quiet in tone, conducted in a rustic hut, with carefully selected unassuming utensils and tea bowls in subdued colors—has been passed on by descendents of the Sen family to the present day. Rikyu may not have been a warrior on the battlefield, but it is said that he conducted his tea ceremonies as if they were a martial art—with precise movements, the proper spacing of utensils, and no breaks of concentration. And he was given the ultimate samurai privilege of being allowed to commit seppuku. The exact reason for Hideyoshi's command for Rikyu to commit seppuku will never be known, but Rikyu took the death sentence with equanimity. He conducted one last ceremony, composed himself, and brushed this death poem:

A life of seventy years	I shout out my last breath!
With my jeweled sword	I kill the Patriarchs.
One possession remains	A single long sword
At this instant of death	I hurl it toward heaven.

Sadler, A. L. *The Japanese Tea Ceremony: Cha-no-Yu and the Zen Art of Mindfulness*. Rutland, VT: Tuttle Publishing, 2019.

SHIMADA TORANOSUKE 島田虎之助 (1814–1852)

Shimada was born in present-day Okayama. At the age of ten, he began to train in swordsmanship, and by the age of fifteen, he was one of the top swordsmen in the district. At age sixteen, he journeyed to Kyushu to train at a different dojo and fell under the influence of the famous Zen master Sengai. Shimada continued to study the sword, Zen, and the Confucian classics in the Shimonoseki area.

In 1838 Shimada went to Edo, intending to become an *uchi-deshi* of the Jikishin Kage Ryu master Otani Nobutomo. Otani was known as the Gentlemen Master. He was physically unimposing, a bit chubby, with an

unassuming demeanor; he had the look of a scholar rather than a swordsman. Otani deliberately let a challenger win one out of three contests in order to encourage the younger swordsman to keep training. He knew that if he swept the matches, it could destroy the challenger's confidence. He did this with Shimada. After the match, Shimada went to another Jikishin Kage Ryu master, Inoue Gensai, to announce the results: "Otani is not that good." Inoue informed him that Otani had let him win and that he should return to the Otani dojo for a rematch. This time, the power of Otani's gaze was so intense it knocked Shimada over before he could strike a blow. Shimada became Otani's disciple. Within a year, the talented student was acting as an assistant instructor. On the side, he trained in Kito Ryu jujutsu at the Suzuki dojo, where he met Katsu Kaishu. Shimada also continued his assiduous Zen training. Sadly, he fell ill and passed away at the young age of thirty-nine.

Sugawara, Makoto. *Lives of the Master Swordsmen*. Tokyo: East Publications, 1985.

Shirai Toru 白井亨 (1773–1843)

Shirai was born in Edo but raised in Shinshu by his uncle. He began training in swordsmanship at age eight, and in 1797, at fourteen, he moved to Edo to enter the dojo of the Itto Ryu master Nakanishi Chuta. The dojo members included such illustrious swordsmen as Asari Matashiro and Chiba Shusaku. For the five years he was there, the diminutive Shirai was known for swinging an extremely heavy wooden sword every night to build his strength.

In 1805, he embarked on a *musha shugyo* (pilgrimage for martial art training). His skill impressed the lord of the Okayama domain so much that he established a dojo for Shirai in that province. In 1811, Shirai reentered the Nakanishi dojo and became a disciple of Terada Munenari, after the sixty-year-old Terada beat the thirty-six-year-old Shirai in a contest. The latter realized that he needed further polishing.

In 1815, Shirai received a teaching license in the Tenshin Itto Ryu. He opened his own dojo in the Shitaya Okachimachi neighborhood of Tokyo and eventually established his own Tenshin Denheiho Ryu. Shirai was

an advocate of Hakuin's Naikan meditation method and tanden forging method. Developing one's *tanden*, the psychophysiological center of a human being located about two inches below the navel, is the key to swordsmanship. Another experience that shed light on the inner principles of swordsmanship was his encounter with the wonder-working monk Tokuhon, the "living buddha of Amida chanting." Tokuhon spent virtually every hour of the day chanting "Hail to Amida" in the most enthusiastic manner. Shirai was deeply impressed by Tokuhon's bearing—it was transparent, as if Tokuhon's physical and spiritual natures had merged, free of any conscious intent. Tokuhon's concentration was so deep and pure that it served as a protective shield. Shirai realized that was the way it should be in swordsmanship. There was no self and no opponent. In later years, Shirai's disciples witnessed sparks of energy radiating from the tip of his sword. Facing him with a sword was said to be a magical experience, as if embraced by a light that felt soft and warm. Shirai died in 1843.

Sugawara, Makoto. *Lives of the Master Swordsmen*. Tokyo: East Publications, 1985.

Shirata Rinjiro 白田林次郎 (1912–1993)

Shirata Rinjiro was born in 1912 in Yamagata. He was from samurai stock and traced his ancestry back to Sugawara Michizane, the patron saint of literature and learning. Even as a teenager, Shirata displayed prodigious physical strength. He could easily toss around a 130-pound bale of rice with a single hand. In high school, he was captain of the judo team and also practiced kendo. His father was a fervent Omoto-kyo follower, so in 1931, when Shirata was nineteen years old, it was decided that he should train under Ueshiba Morihei as an uchi-deshi at the Kobukan dojo. The extremely talented Shirata became a star disciple. He was soon serving as an assistant instructor and was put in charge of the Osaka dojo. In those days, many challengers showed up unannounced at the dojo, and Shirata was designated as the doorkeeper. Many tales are told of such confrontations, with Shirata inevitably coming out on the winning end. He would smile and say, "How can you defeat nonresistance?"

In 1937, Shirata was called to the front in the second Sino-Japanese War.

He later told me, "Ueshiba Sensei taught us that bushido is not learning how to die; it is learning how to live. On the battlefield I realized the truth of that precept. It is due to the death, destruction, and misery of the war that Ueshiba Sensei established aikido to become the Art of Peace that brings the world together."

After being held as a prisoner of war, Shirata was repatriated in 1946. He returned home to Yamagata, married, and raised a family. From 1948 on, he taught small groups here and there in the Tohoku district. In 1969, he established his base in Yamagata prefecture. Shirata was presented with a hand-brushed eighth dan certificate directly from the founder Morihei, and some years later he was promoted to ninth and then tenth dan (posthumously) by Kisshomaru Doshu. Shirata died in 1993. In his later years, Shirata began brushing calligraphies upon request from his students and acquaintances.

Stevens, John. *Aikido: The Way of Harmony.* Under the direction of Shirata Rinjiro. Brattleboro, VT: Echo Point Books & Media, 2019.

SUHARA KOUN 須原耕雲 (1917–2013)

Suhara was born in Tokyo but moved to Hong Kong with his family when he was two. His father operated a Japanese restaurant. Suhara's mother died when he was five, and unable to get along with his father, Suhara ran away from home in fifth grade, boarding a ship to Japan. After a varied career, he was ordained as a Zen priest. In 1949, he was appointed as the abbot of Sokuto-an, a subtemple of ancient Engaku-ji, founded in 1282, in Kamakura. Suhara did not begin the practice of kyudo until he was in his fifties. He built Enman Kyudojo on the grounds of Sokuto-an and became a popular kyudo instructor at home and abroad. With his shaved pate; majestic, perfectly trimmed, white beard; and thin, sturdy frame, Suhara was a Zen master from central casting. His nickname was Bow Monk. He taught in the Awa Kenzo tradition of the Bow and Zen as One.

Decades earlier, Awa had given Herrigel his favorite bow with instructions to burn it upon his retirement. Herrigel's wife could not bring herself to do that, so she passed the bow to Master Anazawa, one of Awa's students. In turn, Anazawa passed it to his senior student, Suhara. The

bow is on display in the Emman dojo. Calligraphy by Suhara is quite rare, similar to the case of Awa.

Kushner, Kenneth. *One Arrow, One Life: Zen, Archery, Enlightenment*. Rutland, VT: Tuttle Publishing, 2011.

SUZUKI SHOSAN 鈴木正三 (1579–1655)

Shosan was born in Mikawa. At age twelve, he was conscripted into the Tokugawa army and later served with distinction in the battle of Sekigahara and the campaign against Osaka Castle. During his furloughs, Shosan studied Buddhism, practiced Zen, and visited various masters. In 1620, at the age of forty-two, he resigned his commission and took ordination as a Buddhist priest. He lived as a wandering mendicant and precept monk for a time and then settled in the mountains near Okazaki to live as a hermit. Shosan advocated Nio Zen, a full-spirited assault on the problems of life with the ferocity of a samurai attack. Hardheaded, practical, and no-nonsense, Shozan downplayed the distinction between priest and layman, and he had little use for enlightenment experiences—"satori that is called satori is no satori." Shosan taught Zen in simple and straightforward language, with a strong emphasis on the practice of Buddhism in everyday life.

Braverman, Arthur. *Warrior of Zen: The Diamond-Hard Wisdom Mind of Suzuki Soshan*. New York City: Kodansha Globe, 1994.

King, Winston L. *Death Was His Koan: Samurai Zen of Suzuki Shosan*. Fremont, CA: Asian Humanities Press, 1986.

TAKAHASHI DEISHU 高橋泥舟 (1835–1903)

Deishu was born in Edo. His father, Yamaoka Masanari, was a high-ranking samurai and famous spear fighter. Deishu began to practice at age six and was one of the best spear fighters in the country by his mid-teens. He was adopted into the Takahashi family when he was seventeen. (Tesshu's situation was the reverse. After Tesshu's master, Yamaoka Seizan, died suddenly in 1855 at age twenty-seven, Tesshu married Deishu's sister, thus becoming head of the Yamaoka family.) Deishu served as an official instructor for the Tokugawa Military Academy at the young age

of twenty-two. After the Meiji Restoration in 1868, he retired from public life and spent his days quietly composing poetry, brushing calligraphy, painting, and acting as an appraiser of antiquities. (He was supported by his brother-in-law Tesshu.) He lived much like a Taoist immortal and was known for his noble character. Deishu's brushwork is highly valued, both for its artistic qualities and for its deep Zen spirit. Regarding martial arts training, Deishu said, "If a fine sword is not polished, it will never show its luster. If you do not practice, you will never master universals and particulars."

Stevens, John. *The Sword of No-Sword: Life of the Master Tesshu*. Boston, MA: Shambhala Publications, 1994.

Takeda Motsugai 武田物外 (1795–1867)

Motsugai was from Iyo (Ehime). He became a Soto Zen novice at age five and began his martial arts training when he was twelve. Motsugai became a martial arts master famed for his prodigious strength—his nickname was Monk Fist because of his ability to leave knuckle marks on thick go boards. Although Motsugai was remarkable for his unequaled physical strength and his martial arts prowess, he was also a wise Zen master and a rainmaker in high demand throughout the country in times of drought. Motsugai founded the Fusen Ryu to propagate his martial arts teachings and brushed zenga to spread his Buddhist message.

Stevens, John. *Budo Secrets: Teachings of the Martial Art Masters*. Boston, MA: Shambhala Publications, 2002.

Takuan Soho 沢庵宗彭 (1573–1645)

Takuan was born into a farm family in Tajima province. At age eight, he became a novice at a Pure Land temple, but at age fourteen he switched to the Rinzai Zen sect. The extremely talented Takuan was later appointed abbot (#153) of Daitoku-ji at age thirty-six, the youngest ever to achieve this rank. Although he was in and out of favor with the powers that be (i.e., both the government and temple authorities) most of his life and was even banished from the capital for some years, he took it all in stride. He had

an extraordinarily wide circle of disciples and acquaintances—emperors, shoguns, daimyo, and legendary swordsmen. Takuan's *Fudochi Shinmyo Roku* (*Record of the Marvelous Power of Immovable Wisdom*) is the seminal text for budo and Zen practitioners.

Takuan died at Tokai-ji in Edo, the temple that had been built for him by the shogun Iemitsu. Just before his death, Takuan brushed his final statement—DREAM. His strict instructions upon his death were, "I leave no Dharma-heir; throw my body away in the mountains; bury it deep in the earth so no one can find it; no sutra chanting; no funeral ceremony; no headstone; no memorial tablet in the temple; no posthumous titles; no mourners; and no biographies! Carry on as usual." No one listened. There are scores of books, in all manner of languages, regarding Takuan's fascinating life and essential Zen teachings.

Haskel, Peter. *Sword of Zen: Master Takuan and His Writings on Immovable Wisdom and the Sword of Taie*. Honolulu: University of Hawaii Press, 2012.

Hirose, Nobuko. *Immovable Wisdom: The Teachings of Takuan Soho*. Warren, CT: Floating World Editions, 2014.

Terayama Tanchu 寺山旦中 (1937–2007)

Terayama was born in Saitama prefecture. He studied Japanese literature at Saitama University and calligraphy at Tokyo Gakugei University. He became one of the top disciples of Omori Sogen Roshi, training in Zen and Jikishinkage Ryu kenjutsu. Terayama was also a disciple of the calligraphy master Yokoyama Tenkei, who inspired him to establish the Hitsuzendo Kai, "Way of the Zen Brush Society."

Terayama served as a professor at Nishogakusha University for many years. He was active on the national and international front teaching Hitsuzendo at many different institutions, organizing exhibitions, and writing many books on calligraphy and art appreciation. Terayama was the leading specialist on the brushwork of Yamaoka Tesshu. He also wrote an influential commentary on Musashi's *Book of Five Rings*.

Terayama, Tanchu. *Zen Brushwork: Focusing the Mind with Calligraphy and Painting*. Translated by Thomas F. Judge and John Stevens. Tokyo and New York City: Kodansha International, 2003.

Ueshiba Morihei 植芝盛平 (1883–1869)

Ueshiba was born in Tanabe, Wakayama prefecture, to a well-to-do land-owner. Rather sickly as a child, he built himself up by swimming in the ocean, engaging in sumo with the other boys, and taking long walks in the woods. Although the young Ueshiba possessed a sharp mind, he did not like being cooped up in a schoolroom and abandoned formal education in middle school. At the Jizo-in temple school, he also trained in Ryobu Shinto, a system combining esoteric Shinto with tantric Buddhism, eventually receiving an *inka* (certificate of attainment) from the abbot, Fujimoto Mitsujo. In 1901 his father sent the nineteen-year-old Ueshiba to Tokyo with the financial wherewithal to start a business. The young man was back home, penniless, in less than a year.

In 1903, Ueshiba was called up for military duty. He served on the Manchurian front during the Russo-Japanese War and was discharged in 1906. During these years, Ueshiba was training in various martial arts, traditional and modern. In 1910, he supported the eccentric scholar Minakata Kumagusa in the Anti-Government Shrine Consolidation movement. The national government hatched a grand scheme to develop Hokkaido, and in 1912, Ueshiba headed a continent of eighty-five pioneers to settle in the far north of the island. There Ueshiba met Takeda Sokaku, grandmaster of Daito Ryu Aiki-Jutsu, who dominated him despite the master's small build and middle age. Ueshiba immediately became his disciple. Learning that his father was seriously ill, Ueshiba turned all his property over to Sokaku and left Hokkaido for good.

On his way home, Ueshiba made a detour to visit Ayabe, headquarters of Omoto-kyo. He encountered Deguchi Onisaburo, the Grand Guru. Ueshiba and his wife and children moved to Ayabe in 1920. Encouraged by Onisaburo, who immediately discerned that Ueshiba's mission on earth was "to teach the world the true meaning of budo," a dojo was built on the Ayabe compound. After many adventures, Ueshiba had a transformational mystical experience in the spring of 1925. Following this enlightenment experience, his techniques ascended to a higher level, and his amazing ability was soon recognized by all. Ueshiba was invited to teach martial arts at a number of the top military academies. However, well aware of the

contradiction between his views on peace and his participation in the war effort, and sickened by the death, destruction, and misery of the fighting, he resigned all his commissions and retired to a small farm in the town of Iwama in 1942. There he had the Aiki Shrine constructed, waited for the inevitable conclusion of the war in 1945, and prepared for the coming of a new era in which aikido, the Way of Harmony, would play a central role. Ueshiba continued training right up to his death from liver cancer at eighty-six.

Stevens, John. *The Essence of Aikido: Spiritual Teachings of Morihei Ueshiba*. Tokyo and New York City: Kodansha International, 2013.

Stevens, John. *Invincible Warrior: A Pictorial Biography of Morihei Ueshiba, the Founder of Aikido*. Boston, MA: Shambhala Publications, 1999.

Wang Xizhi (Wang Hsi-chih) 王義之 (303–361)

Wang was born into the illustrious Wang clan in Shan-tung province. He began the practice of calligraphy at age seven under the esteemed calligrapher Lady Wei (272–349). She taught Wang the basic principles of composition, the proper use of brush and ink, and the flow of the characters. Lady Wei's graceful calligraphy was described as resembling a beautiful young girl dancing. Wang studied with her for five years. Thereafter, he assiduously copied a wide variety of classical styles. Similar to Hirayama Shiryu, whose house was packed full of weapons and books of all sorts, Wang's calligraphy tools were stuffed everywhere—in his study, the courtyard, the hallway, even beside the toilet. In the public realm, Wang's highest official position was general of the Right Army.

Although it is believed that none of his formal pieces survived—it is said that Emperor T'ai-tsung loved Wang's most famous work *Orchard Pavilion Preface* so much that he ordered exact copies to be made and had the original buried with him—thousands of faithful copies were made through the centuries. Interestingly, a few of the characters of the *Preface* are smudged, and a couple are crossed out and replaced with the correct character. The work was not textbook perfect (Wang was tipsy when he wrote it), but that added to its allure. The next day, the sober Wang tried to copy out an improved version, but it was nowhere near as good as the

spontaneous original. Although his formal works have disappeared, more than seven hundred "jottings" believed to be in his hand are extant. These consist of letters to friends and relatives, random notes on various topics, shopping lists, request for medicines and herbs, complaints about politics or his health, and the like. In some ways, this type of calligraphy is considered even more valuable than formal compositions, because the brushwork more accurately conveys the true, unadorned character of the calligrapher.

Wang spent his last years in quiet retirement—sightseeing, fishing, and gathering medicinal herbs.

YAMADA JIKICHIRO 山田次吉郎 (1863–1930)

Yamada was born in Chiba prefecture. Against his family's wishes, he went to Tokyo to train in kenjutsu at the dojo of the famous master Sakakibara Kenkichi. Weak and scrawny, Yamada built himself up to become one of the strongest members of the dojo. During a snowstorm, Sakakibara and Yamada were walking home after teaching, when the thong of Sakakibara's geta snapped. Yamada was able to check his master's fall while simultaneously slipping off his own geta and sliding it under Sakakibara's foot for him to step into. Sakakibara was so impressed by Yamada's reflexes that he designated his disciple the fifteenth headmaster of the Jikishin Kage Ryu. Yamada took over operation of the dojo when Sakakibara died. In 1904, Yamada opened his own dojo, the Hyakurenkan.

Yamada was an influential figure in the early twentieth-century kendo scene. However, he didn't participate in the promotion of "competitive sport" kendo. Yamada compiled a huge, neatly arranged library—he had copies of most of Hirayama Shiryu's numerous books. During the Great Kansai Disaster of 1923, Yamada piled his library into a cart but then realized it was more important to transport people to safety than books. The library was left behind, and everything was lost, including all the documents relating to the Jikishin Kage Ryu. As a consequence, Yamada did not designate a successor, and the formal transmission of the Ryu ended with Yamada's death.

Sogen, Omori, and Terayama Katsujo. *Zen and the Art of Calligraphy: The Essence of Sho*. Translated by John Stevens. London: Routledge, 1983.

YAMAOKA MATSUKO 山岡松子 (1873–1928)

Yamaoka Matsuko was Tesshu's eldest daughter, and like several of his children, she was an accomplished artist. Matsuko often did paintings that her father inscribed. She practiced kendo in Tesshu's dojo when she was young and was said to have been a woman of talent and high spirit. Her pen name, Kokoku, means "Fragrant Valley."

YAMAOKA TESSHU 山岡鉄舟 (1836–1888)

Tesshu, born as Ono Tetsutaro to a samurai family in Edo, spent his youth in Takayama (Gifu). He displayed an early talent for swordsmanship and calligraphy, and he began sitting zazen at age thirteen. When he was seventeen, Tesshu returned to Edo to perfect his swordsmanship by training at various dojo. A huge, powerful man and confident in his ability, he was a demon swordsman. However, when he was defeated by the much smaller and older Asari Gimei, Tesshu realized that it was the mind, not the body, that determined the outcome. He studied Zen under the Zen master Tekisui and eventually had a great awakening at the age of forty-five. Tesshu received inka from both Asari and Tekisui. He founded the Muto Ryu (No-Sword School) to promote his ideas of the Sword and Zen as One.

Before he retired to devote himself to the sword and the brush, Tesshu was an important public official, serving as a trusted aid to Emperor Meiji. (Tesshu is famous for throwing and pinning the drunken Meiji when the emperor tried to attack him, saying, "I don't care who you are. You have to learn how to behave yourself when you drink.") Tesshu was the most prolific of Zen artists. In a short period of ten years, he produced at least a million zenga, carefully recorded by his disciples, at an average of about five hundred a day. He did so to endow temples he founded or restored and to raise money for many worthy causes. Tesshu entered eternal meditation while sitting zazen. Five thousand people attended his funeral.

Moate, Sarah, and Alexander Bennett, eds. *Ken Zen Sho: The Zen Calligraphy and Painting of Yamaoka Tesshu*. Tokyo: Bunkasha International, 2014.

Stevens, John. *The Sword of No-Sword: Life of the Master Tesshu*. Boston, MA: Shambhala Publications, 1994.

Tesshu, Yamaoka. *Yamaoka Tesshu: Zen and Swordsmanship from the Yamaoka Tesshu Archives*. Edited by Leslie Higley. Tokyo: Zensho-an, 2009.

CREDITS

Many of the photos in this book are part of a private collection. The others are provided thanks to the generosity of the following contributors:

Albert Mercado Collection
Alexander M. Greene Collection
Andy Kay
Ben Johnston
Beth Frankl
Christine Kilian
Christopher Foreman
Eamonn Devlin
Eisei Bunko
Gordon and Patrica Greene Collection
Jinichi Tokeshi, MD
Joshua Mitchell Collection
JS Collection
Kaeru-An Collection
Kenneth Kushner Collection
Kevin Nakashima
Leslie Wright Collection
Milard Roper Collection
Naej Foundation
Richard S. Bowles
Robert Matsueda
Robert Noha
Swami Ishwarananda Collection
Terayama Tanchu
Wolf Nickel Collection

ABOUT THE AUTHOR

John Stevens lived in Japan for thirty-five years, serving as a professor and aikido instructor at Tohoku Fukushi University in Sendai. He has authored and translated numerous books on a wide variety of subjects, including Buddhism, martial arts, poetry and literature, biography, sacred sex, Asian calligraphy, and Zen art. He has curated and published exhibition catalogs on Zen art in the United States, Germany, the Netherlands, Belgium, Spain, and the Czech Republic.

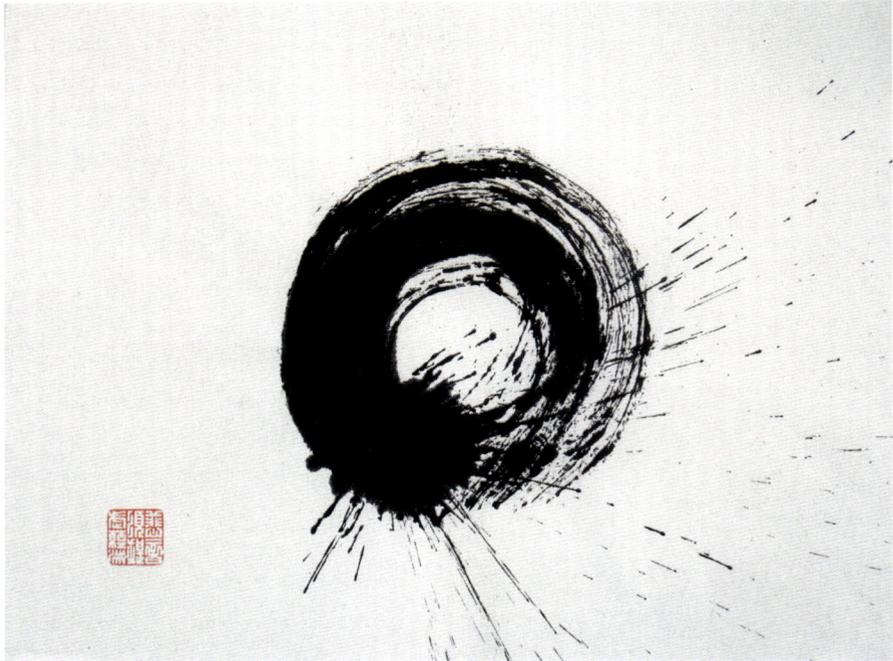

Enso by John Stevens